POSTCARD HISTORY SERIES

Davenport

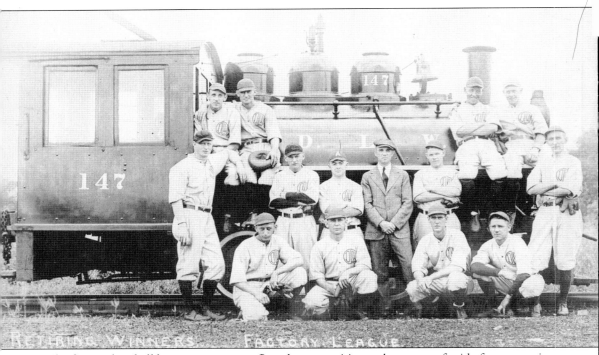

The factory baseball league teams were fiercely competitive and a source of pride for sponsoring businesses. Above is the *c.* 1910 team from the Davenport Locomotive Works. Baseball had been a local pastime here since the 1860s. In a game played between Rock Island and Davenport in 1866, the Davenport club was on the short end of a 119-7 score.

On the front cover: In the early days of firefighting, the men on the fire department were a source of pride and an indication of town physical fitness. City fire departments often entered contests against each other in events designed to test their skill, ability, and strength. In this *c.* 1915 Firemen Tournament Parade, team entries march past the St. Louis House (402 West Second Street), H&H Rohlff Hardware and Cutlery (332), B. F. Muhs Brothers Clothing (326), R. Bretscher Shoe Company (312), and "S&L" Simon and Landauer Clothing (228). The first hook and ladder company had been organized in Davenport in 1840 when the population was only 600. In 1920, the city had 61 firemen, 54 policemen, and 32 post office letter carriers. (Author's collection.)

On the back cover: This confectionery sold postcards as well as candies, ice cream, and lunches. The two large posters in the windows advertise the coming "Buffalo Bill's Wild West and Pawnee Bill's Far East Shows" appearing in Rock Island on Tuesday July 23, around 1908. (Author's collection.)

POSTCARD HISTORY SERIES

Davenport

Doug Smith

ARCADIA
PUBLISHING

Published by Arcadia Publishing
Charleston SC, Chicago IL, Portsmouth NH, San Francisco CA

Printed in the United States of America

Library of Congress Catalog Card Number: 2007931981

For all general information contact Arcadia Publishing at:
Telephone 843-853-2070
Fax 843-853-0044
E-mail sales@arcadiapublishing.com
For customer service and orders:
Toll-Free 1-888-313-2665

Visit us on the Internet at www.arcadiapublishing.com

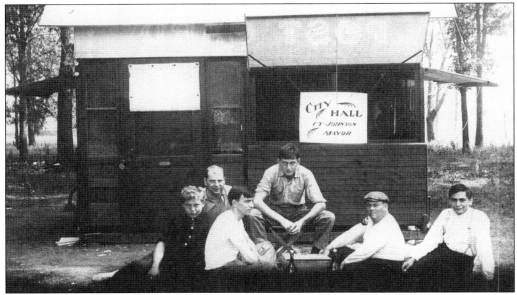

Picnickers and swimmers loved to spend time on Suburban Island. The city directory at that time listed its location as a half mile west of the Crescent Bridge. Originally known as Credit Island from the days of Native American fur trade, it was the site of a military battle in 1814 between the United States troops of Maj. Zachary Taylor and the British troops with support from the local Native Americans. In 1914, at the 100th anniversary of the battle, it was suggested by speaker William A. Meese that the name revert back to Credit Island, an act that took place soon after. Judge Meese was a true supporter of the community and an author of local history who founded the Rock Island County Historical Society.

CONTENTS

ACKNOWLEDGMENTS

Davenport was a wonderful place to grow up during the 1960s and 1970s. Neighborly Iowa people, caring teachers, the anticipated change of seasons, neighborhood parks, playgrounds, athletic competition and schools, and so many other things contributed to a childhood that I would not trade for the world. All those wonderful memories with family and friends, and the fondness for my past, are what endear me to this place. How interesting it is that when asked of the meaning of the word *Ioway*, Native American interpreter Antoine LeClaire defined it as simply "this is the place." And how apropos that after visiting Davenport over 100 years ago Pres. Millard Fillmore told its citizens "If there is a paradise on earth—it is here." How true and how blessed I was to be a part of it. I hope these historic penny postcards, early photographs, and other pieces of Davenport's past can take you to a place of long ago, when life was simpler, slower, and dare I say, better.

Davenport in the Postcard History Series is the culmination of months of pouring through my personal collection of favorite postcards and photographs and many enjoyable evenings of research and documentation. Any undertaking of this nature can only best be done with the help of others. I would be remiss if I failed to extend my heartfelt gratitude to my loving wife, proofreader, and gentle critic, Christine, and good friend and fellow student of local history Frank "Monte" Weidenfeller, who were of immeasurable help in keeping this book fun, interesting, and factual.

INTRODUCTION

This book is intended to be an educational, interesting, and fun look backward, but by no means a detailed historic account. However, a brief synopsis of the beginnings of our town is in order.

The earliest accounts of human settlement on what is now the site of Davenport can be traced to the writings of the French explorers Jacques Marquette and Louis Joliet during their historic voyage from the Great Lakes to the Gulf of Mexico. On June 21, 1673, seeing footpaths of mortals on the western bank of the Mississippi River, they lit ashore very likely at the spot now occupied by the city of Davenport and made council with the tribe of the Illini. Native folklore indeed recognizes the area as that of populous Native American villages from time immemorial, and likewise confirms it as the location of the landing of the first white man on Iowa soil. Furthermore, during early excavations throughout the city, Native American graves were found buried with ancient artifacts corroborating the testimony of their tradition.

Sometime after 1730, a Musquakie (Fox) village was located here with their allies the Sacs (Sauk) inhabiting the Illinois side of the Mississippi. The French had forced both tribes from their lands in southeastern Michigan. During the Revolutionary War, in 1780, the Musquakie warriors, who were always in support of the British, applied war paint and left their village here called Oshkosh (later Morgan) to support British troops in an attack on Cahokia and Pencour, later known as St. Louis. In retaliation, Col. George Rogers Clark sent a detachment of men who fought off 700 fighting braves and according to his accounts burned the towns of the Sauk and Fox. At some time thereafter, the Sauk and the Fox Indians reestablished their villages on Illinois soil. Saukenuk, the principal village of the Sauks, was located on land between the junction of the Mississippi and the Rock Rivers. Previously, however, they had ceded the land to the United States in 1804, and they were living there on borrowed time. In the summer, they would cross the river for their annual buffalo hunt on the plains of Iowa, described by early explorers as open prairie, wild grass to the knees, and an abundance of animals. Wildlife there included grizzly and black bear, lynx, bobcat, elk, moose, wolf, and antelope. The Native Americans' last big buffalo hunt in the vicinity occurred in 1816, when they chased them into the river at the foot of where Brady Street now sits, killed them, and pulled them ashore. However, as the white man progressed westward, expanding claim to the land now rightfully his, he continually drove the Native Americans out.

Periodic skirmishes with the Native Americans compelled the government to order the erection of a military fort here in 1816 to keep them in check. Fort Armstrong was constructed on Rock Island, located between the cities of what are now Davenport and Rock Island, Illinois. It was named in honor of John Armstrong, a major general in the Revolutionary War. The agent sent to supply troops with provisions was George L. Davenport. The Native Americans called him

Saganosh or "He is an Englishman." His wife and two other women were the first white women in these parts. George Davenport was content at first to provide provisions for the troops only, but by the second year had begun to trade with the Native Americans. Discovering this was no easy task, 20-year-old Antoine LeClaire was summoned to act as interpreter. Born in 1797 the son of a French Canadian father and Pottawatomie mother, LeClaire spoke French, Spanish, English, and a dozen or more Native American dialects. About 1830, the Native Americans were forced to relocate on the Iowa shore as encroaching white settlers made increasing claim to land in Illinois. They were pushed from their homes, fertile fields, and hunting grounds that they had known for more than 100 years. Indignant braves, led by their warrior Black Hawk, initiated several bloody battles until the final campaign in 1832 known as the Black Hawk War. With the capture and imprisonment of Chief Black Hawk, and the near complete annihilation of his people, the signing of the Black Hawk Treaty transferred six million acres of Iowa land to the United States at 9¢ per acre. Black Hawk was held in prison and was not given the honor or respect of signing the document that bears his name. Chief Keokuk, a rival of Black Hawk, was instead chosen by the United States government to represent the tribes, adding further humiliation to their once proud leader and warrior. LeClaire served as interpreter and translated Native American speeches at the historic event. It was said that no white man was more intimately associated with or trusted by the Native Americans.

In appreciation for his long friendship, the Native Americans gave LeClaire two tracts of land, one in what is now LeClaire, Iowa, and the other, a square mile of land given to his wife, Marguerite, on condition that LeClaire should build his house on the spot where the treaty was signed (at approximately Fourth and Farnam Streets). This was fulfilled the following year, the house being the very first built in this vicinity on the Iowa shore. A few years after the land gained from the "Black Hawk Purchase" was opened to squatters, a group of eight men, including LeClaire, agreed to the terms for the founding of the town of Davenport on February 23, 1836. LeClaire, who held title to the land, sold it to the group for an investment of $250 each. The original plat consisted of an area of 36 blocks and 6 half blocks and included 3 square blocks and riverfront land set aside for public use. At that time, there was only one public road, Front Street along the river, and a couple of old Native American trails that ran through town and up the bluff; not one person lived anywhere within the city boundaries. Maj. William Gordon, a United States surveyor and member of the founders group, made the original survey of the land on May 14. An eyewitness claimed that Gordon was drunk when he made the survey and errors in the original plat later caused difficulty, making a resurvey necessary on April 3, 1841. At the close of 1836, there were only six houses lying within the original limits of the town, and the population was less than 100. With the threat of Black Hawk eliminated, the garrison at Fort Armstrong was removed in 1836. Black Hawk was released to spend the last few years of his life with his wife, peacefully farming on land near Des Moines. Before his death in 1838, however, Chief Black Hawk once again would call on his friend LeClaire, entrusting him to record his life story for generations of both Native Americans and white men to come.

One

EARLY IMAGES, THE
PRE-POSTCARD ERA

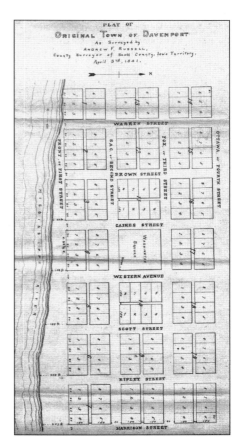

Shown is an early copy of half of the second survey of Davenport; the original was done on May 14, 1836. The plan for the city was unique in that alleys ran in different directions, and Western Avenue was designed to be 100 feet wide, 20 feet wider than the others. Western Avenue was to be the business center of the city and main thoroughfare—something that never did materialize. The Native American street names such as Sac, Fox, and Ottawa suggested on the survey were abandoned in favor of sequentially numbered streets from south to north. On July 3, 1836, this land became part of the new territory of Wisconsin. Two years later, on July 4, 1838, Iowa was made its own territory, whose borders extended to Canada, including most of Minnesota and about half of North and South Dakota. Finally, Iowa was further divided and distinguished as the 29th state of the union on December 28, 1846, a full 10 years after Davenport's initial platting.

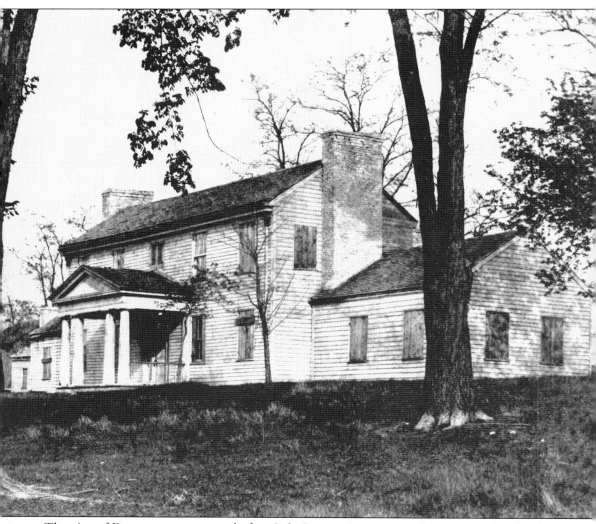

The city of Davenport was named after Col. George Davenport, who was murdered at his home (shown above) during a robbery on July 4, 1845. The criminals were apprehended, and a public triple hanging occurred at the Rock Island County Court House. Davenport was buried behind his home, and his family continued to live there until the property was purchased by the government in 1866. At that time, his body was exhumed and laid to rest at Chippianock Cemetery in Rock Island. In this view from the 1880s, the house is abandoned and boarded up. By the 20th century, the house laid in ruins. Today it has been restored and can be viewed and toured on Arsenal Island. Built in 1833, it is the second-oldest home in the "Quad Cities" area. Only the original "claim house," built by his son on Iowa soil in 1832, is older.

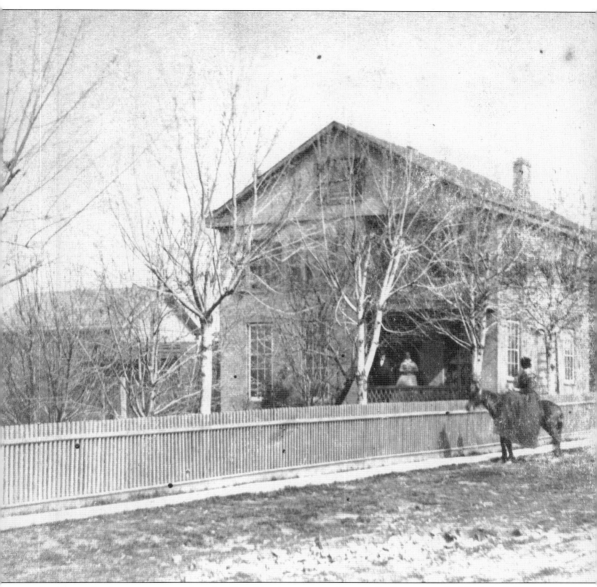

In the early days, even people who lived in the center of town had pastures behind their homes for grazing cattle. Hogs roamed about the streets uprooting fences, covering wooden sidewalks with mud, and generally creating havoc. Accidents from runaway horses were frequently reported. In 1839, to improve sanitation, an open sewer was dug right down the middle of Harrison Street to carry filth directly into the river. In fact, the street thereafter was referred to as Ditch Street. The streets were poorly graded with many trees and stumps as obstacles. Mud puddles, deep holes, and ruts were everywhere. A city ordinance was passed ordering the removal of all fences and obstructions blocking streets and alleys, and another ordinance forbade throwing manure, spoiled meat, offal, decayed vegetable substance, and dead animals into any street, alley, or public square. As late as 1854, there were no dandelions in the area until people sent to Pennsylvania for seeds. Though gas lighting was being installed in homes and businesses by 1855, the city council voted to pass a law prohibiting their lighting on clear nights.

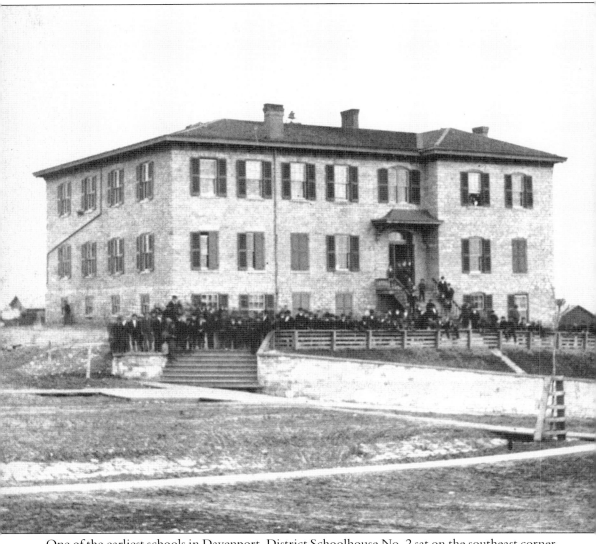

One of the earliest schools in Davenport, District Schoolhouse No. 2 sat on the southeast corner of Seventh and Perry Streets in 1855. District No. 2 embraced the part of the city east of Harrison Street and south of Tenth Street. In October 1855, there were 894 children in the district, of which only 150 were in attendance in public schools. Some children attended parochial or private schools, but the majority did not attend at all. William Gould was the one sole teacher at No. 2, and he had two female assistants. There were only three public schools in Davenport at that time, none designated as junior high, intermediate, or high schools. This school was later named Adams after John Adams, the second president of the United States.

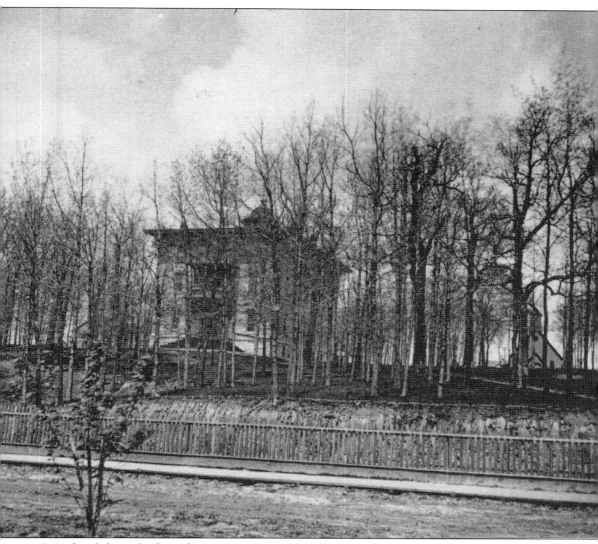

Completed about the first of June 1856, Griswold College was divided into three academic terms per year, with tuition at $6 per term for preparatory school or $8 per term for the collegiate department. Located between Brady and Harrison Streets and between Tenth and Twelfth Streets, the college sat on eight acres and was actually the second site for the school in Davenport, which when chartered in 1847 became the first institute of higher learning west of the Mississippi River. The upper (third) story contained 12 rooms for students. Students were accommodated in the school for $1.50–$2 per week depending on conveniences required. Young men of limited means could assist themselves by having manual employment a few hours each day. Later known as Iowa College, it included Kemper, Wolfe, and Lee Halls on the campus of what became Davenport Central High School. St. Katherine's Hall, which was opened on September 24, 1884, was also part of the college, though at a different location. In 1900, the property was sold, and the school was removed to Grinnell and is now known as Grinnell College.

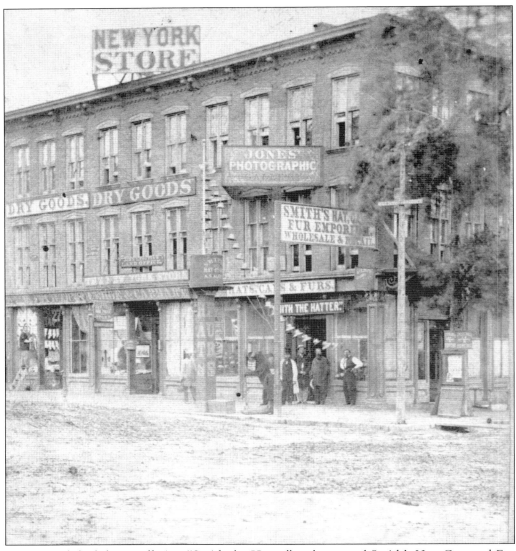

H. G. Smith had the appellation "Smith the Hatter" and operated Smith's Hat, Cap, and Fur Emporium on the southeast corner of Second and Main Streets (31 West Second Street). This is where the historic Petersen and Sons' Department Store or Redstone Building stands today. The building was shared with Jones' Photographic Gallery and attorney D. A. Dittoe. The New York Store was run by Thomas Kehoe and L. B. Carhart at 29 West Second Street, where they sold dry goods of all kinds and shared the building with the land office of John L. Coffin. These businesses were part of the building known as the Atkinson Block. In those days, a block referred to a larger building named after the owner or builder. The municipal building numbering system began in 1856, but house and business numbers below 100 were discontinued in the 1870s when structures built immediately east of Brady Street were designated 100 block east, and immediately west of Brady Street, 100 block west.

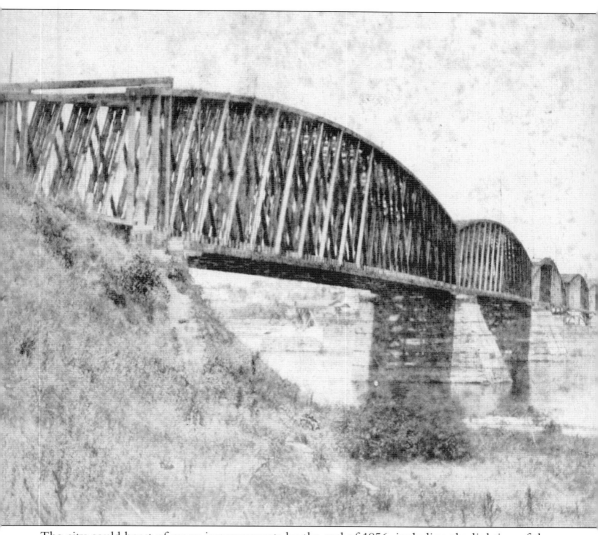

The city could boast of many improvements by the end of 1856, including the lighting of the city with gas, the laying of sidewalks, the opening of the Mississippi and Missouri Railroad to Muscatine and Iowa City, and the completion of the railroad bridge across the Mississippi River. The Mississippi and Missouri Railroad Company was organized in 1853, and construction on the first bridge of any kind over the Mississippi began in January 1854. City founder Antoine LeClaire turned the first shovel and donated the land and his home built years earlier as the first depot. The entire cost of the structure was about $350,000. The draw of the bridge was first swung on April 9, 1856, at 6:00 p.m. On April 21, the new locomotive *Des Moines* crossed from the island to Davenport shortly after 7:00 p.m., which was the first passage, and a train of freight cars immediately followed. The following morning, the regular 8:00 a.m. passenger and freight trains from Chicago crossed as well, in so doing signaling the beginning of a new era in westward expansion.

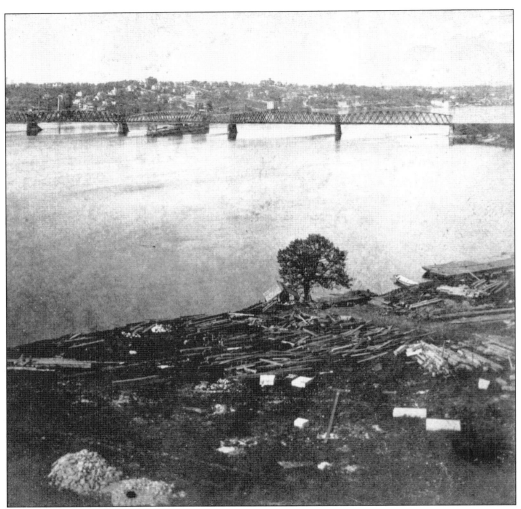

This view from the city of Rock Island shows Davenport on the opposite shore. The first Rock Island Railroad Bridge is easily recognizable from its single-deck trussed-arch design. Oddly enough, the first locomotive in Iowa did not cross the newly completed bridge but had been ferried over about 11 months before the bridge was completed. Late in 1855, they finished building a line from Davenport to Iowa City (the state capital at that time) with plans to continue to Fort Des Moines and Council Bluffs. The first train to operate in Iowa went from Davenport to Muscatine with six crowded coaches on November 20, 1855. It was pulled by two locomotives aptly named the *Davenport* and the *Muscatine*. The first train to reach Iowa City did so on January 1, 1856, and began running regularly on January 6. Freight and emigrant trains left and arrived at Davenport for Muscatine and Iowa City once per day, while passenger trains left and arrived twice daily.

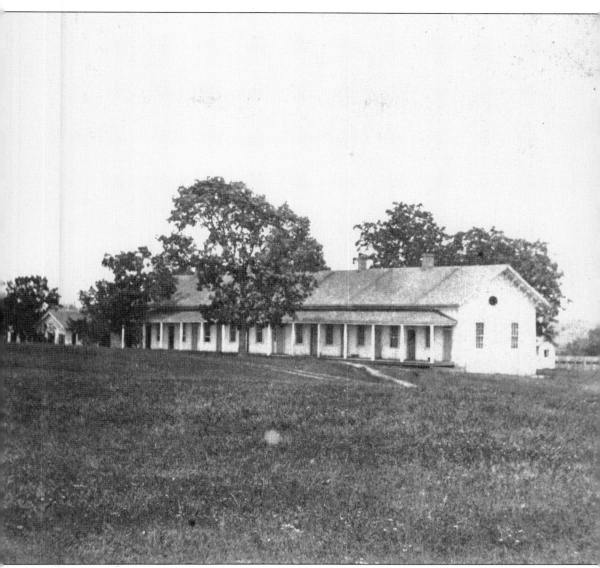

In 1861, at the start of the Civil War, Davenport was the western terminus of the telegraph system and therefore was made Iowa's military headquarters. Five camps were set up and built in haste around town to accommodate soldiers receiving their military training here. Camp Roberts (renamed Camp Kinsman), shown above, was one such camp and was built on the northern edge of the city limits. The camp was used only briefly, and in 1863, when community leaders were planning an Iowa Civil War Soldiers' Orphans Home, the abandoned camp seemed like a fortuitous fit for their purpose. Annie Wittenmyer headed a committee that secured approval for the acquisition and conversion of the almost new, but abandoned, Camp Kinsman army barracks in the fertile farmland outside Davenport. She left Davenport in 1867, however, to continue her humanitarian causes and died in 1900. In 1949, the facility was renamed the Annie Wittenmyer Home in her honor.

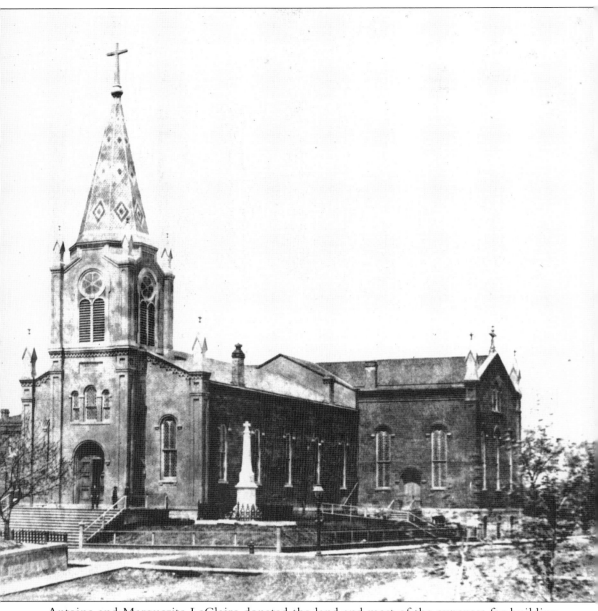

Antoine and Marguerite LeClaire donated the land and most of the expenses for building St. Margaret's Church located at Tenth and LeClaire Streets. The cornerstone was laid on June 29, 1856. Both were buried in the churchyard, the large tomb of which can be seen in the photograph above. Antoine died in 1861, and at the time of his death, his estate was valued at $444,000, a huge sum in those days. When St. Ambrose College was established in 1882, classes were held here for the first three years until the school building was completed in Noel's Grove on West Locust Street. Later when a larger church was needed, Sacred Heart Cathedral was erected here in 1891 and the graves of Antoine and Marguerite were transferred to St. Marguerite's Cemetery (now Mount Calvary).

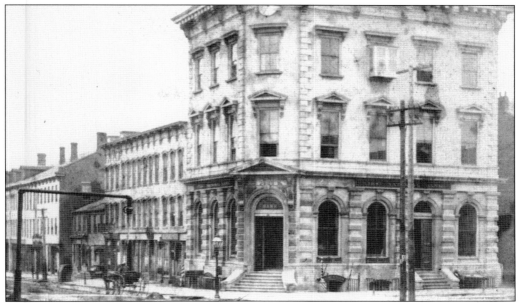

On Monday, June 29, 1863, the First National Bank in Davenport became the first of its kind in the entire United States, opening two full days before any other First National Bank in the country. In 1923, this building, like many in those days, suffered from a disastrous fire, which completely destroyed the structure and contents. Built on the southwest corner of Second and Main Streets, the United States Bank occupies the same location today.

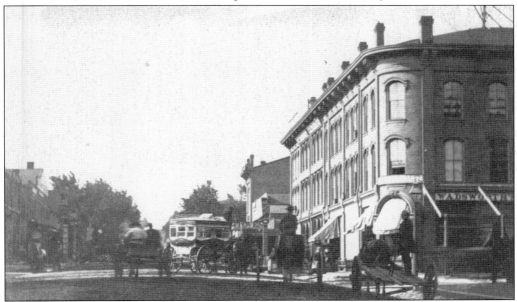

This scene, looking north on Brady Street at Second Street, pictures a stagecoach en route. The Western Stage Company was located on the south side of Second Street, west of Brady Street. A splendid omnibus bearing the designation "Davenport Express" ran to east Davenport at 6:30 and 10:00 a.m. and 2:00 and 6:00 p.m. It also made trips every morning and evening to the Rock Island Railroad Depot.

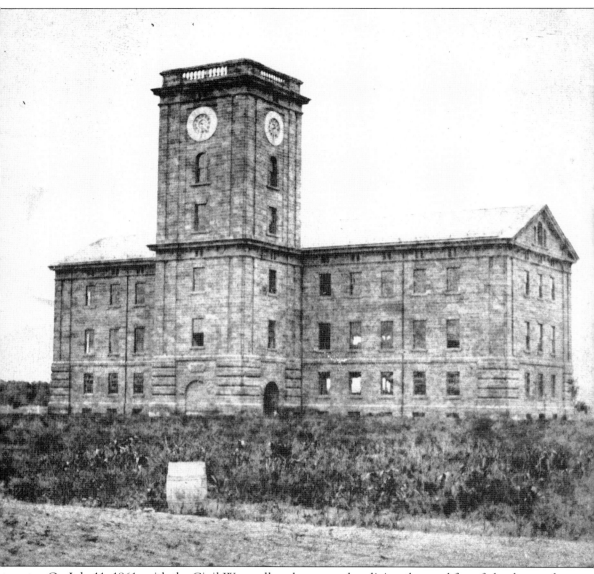

On July 11, 1861, with the Civil War well underway and realizing the need for a federal arsenal in the upper Mississippi Valley beyond the reach of the Confederate armies, Congress passed an act authorizing the establishment of the Rock Island Arsenal. Oddly enough, however, none of the arsenal buildings were completed during the course of the war. Construction began on Storehouse A, or the "Issuing Store House" (shown above), near the ruins of Fort Armstrong, in 1863. This was the first permanent structure built on Rock Island, and today it is commonly called the Clock Tower Building. Though started in 1863 and finished in 1867, the date of 1865 is permanently inscribed on it. Later the streetcar lines, which ran on a strict schedule, were referenced to arsenal time. When the bell struck the hour, the toll was so loud that citizen complaints compelled the government to muffle its ring.

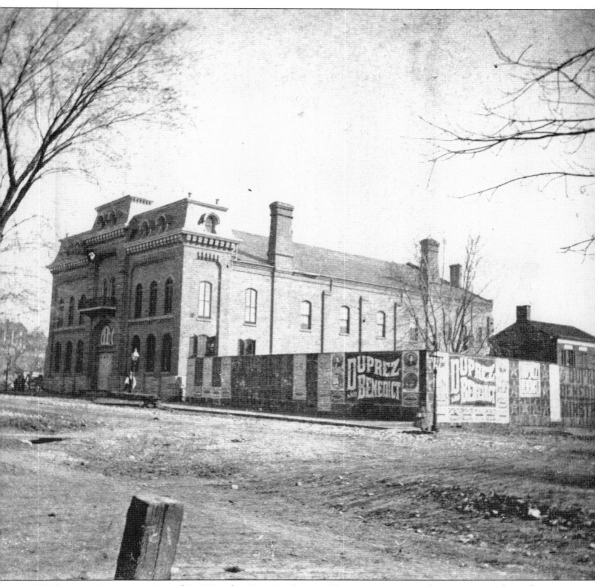

With a seating capacity of 1,400, the Burtis Opera House was once the premier place for entertainment in the entire West. The grand opening occurred on December 26, 1867, and over the years, the stage featured the greatest voices, vaudevillians, hoofers, bands, elocutionists, and entertainers of all types of the 19th and early 20th centuries. The broadsides placed over the fence advertise the coming attraction of the Duprez and Benedict Minstrel Show. On February 19, 1891, Henry M. Stanley, the man who discovered Dr. Livingstone in Africa, gave an account of his daring adventures at the Burtis Opera House. James Whitcomb Riley, American poet, appeared there in 1900. And P. T. Barnum created one of the most popular acts to ever play the Burtis Opera House, when overflow crowds thrilled with delight from the curiosities of his famous midgets: Mr. and Mrs. General Tom Thumb, Commodore Nutt, and Minnie Warren. This photograph was taken at the spot of the Second Baptist Church, and the Kimball House Hotel would replace the billboard fence in 1874.

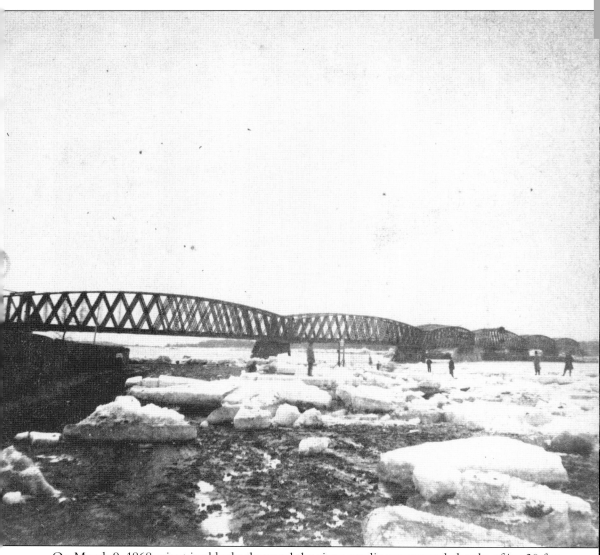

On March 9, 1868, giant ice blocks dammed the river, sending water and chunks of ice 30 feet long careening through the city streets. At the Scott House Hotel, located on the northwest corner of Harrison and Front Streets, water poured in so fast that bread was left in the oven baking as people ran for their lives. Across the street, a fire broke out at W. H. Claussen's Lime House, but firemen, unable to reach it, could only watch it burn. Houses and businesses were pounded and destroyed, and at the French and Davis Lumber Mill, a half million logs were dislodged from their moorings and shot like missiles through the agitated waters. The railroad bridge buckled, suffering considerable damage, as the wind toppled the turn span into the water.

At the pinnacle of the jam, blocks of ice as large as boxcars were piled so high that the city of Rock Island could not be seen from the Davenport shore except from the tallest buildings.

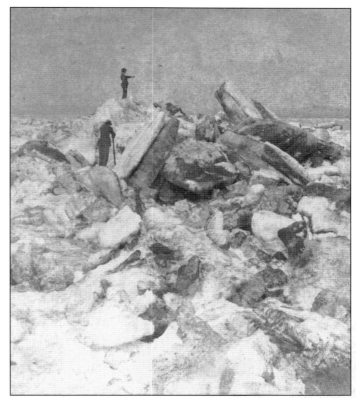

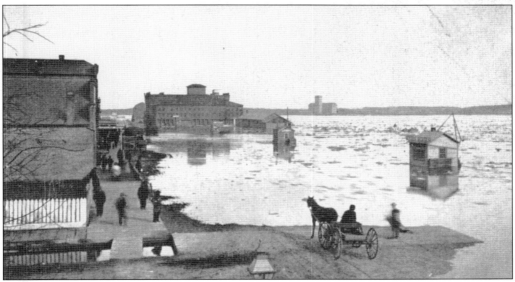

Another view taken after the great ice gorge shows the 15-foot board sidewalks, gas streetlight, open street gutter, harness shop, and Arsenal Clock Tower in the distance. The sidewalks were often a hazard to pedestrians, as they were commonly in disrepair. Furthermore, they sometimes acted as conduits to fire, helping to spread flames quickly between burning buildings. This view was taken at the foot of Harrison Street.

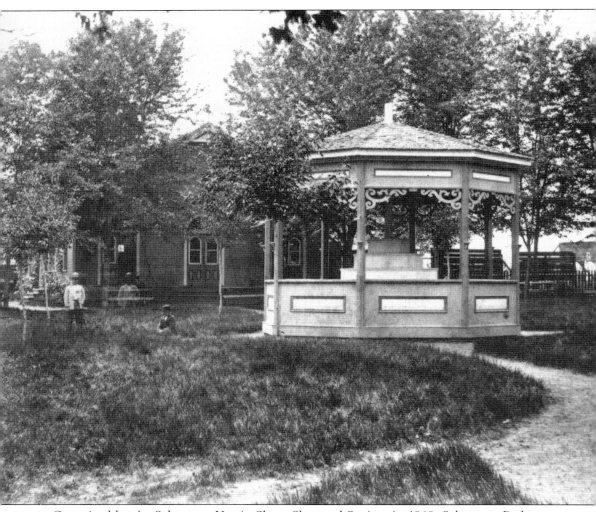

Organized by the Schuetzen Verein Sharp Shooters' Society in 1868, Schuetzen Park was a favorite attraction of the German American community for many years. Besides the shooting range, target houses, and beautiful setting, it featured an inn with a fine restaurant, bowling alley, music pavilion, zoo, roller coaster, athletic field, and picnic grounds. The concluding concert of the Saengerfest (singing festival) in July 1898 was held at the park and attracted 12,000 spectators. The park, however, suffered during the anti-German resentment of World War I, and its name was changed to Forest Park. With attendance falling, the park was again dealt a financial blow with the loss of alcohol sales during Prohibition, and after struggling for years, the site was sold and occupied by a chiropractic sanatorium. In 1960, most of the grounds were sold to the Davenport Good Samaritan Center, a nursing home still in operation today. The Davenport Schuetzen Verein continues as an active organization and is recognized as the oldest continuously operating German Shooting Society in the United States.

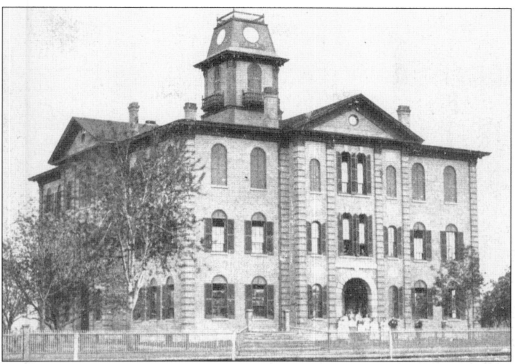

School No. 5 was built in 1868 on the south side of Third Street, west of Ainsworth Street (now Washington Street). Later named Monroe School, it served as an elementary school through 1939, when it was replaced with a new building located on West Fourth and Cedar Streets. The old building was torn down and today is the site of Monroe Park, near Harris Pizza No. 3.

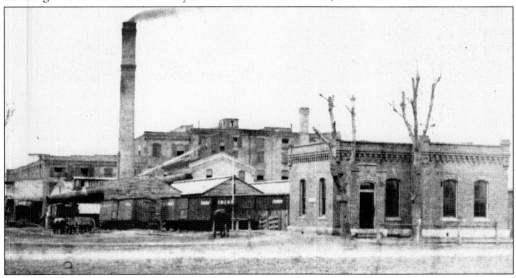

The Davenport Glucose Factory began operation in 1873 west of the city cemetery on Rockingham Road and Division Street. It operated for decades as one of Davenport's most successful businesses manufacturing grape sugar, glucose, and table syrup. Unfortunately, a large explosion and fire in 1897 took the lives of four, and the plant burned to the ground.

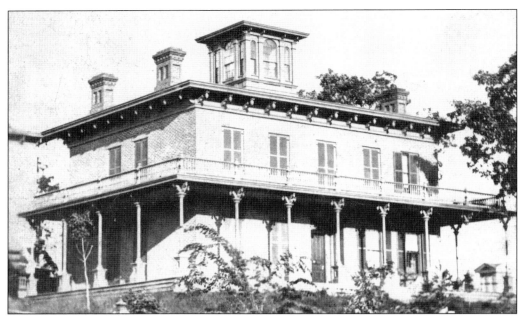

The wealthy built their homes on the bluff affording the most spectacular views of the city and river. John H. Berryhill, vice president of the Davenport National Bank, lived in this home at 627 Brady Street in 1869. Home and business fires were always a looming concern. In the early days of the town, all occupiers of houses were required to keep two leather buckets on hand at all times for fire protection or face a 50¢ fine.

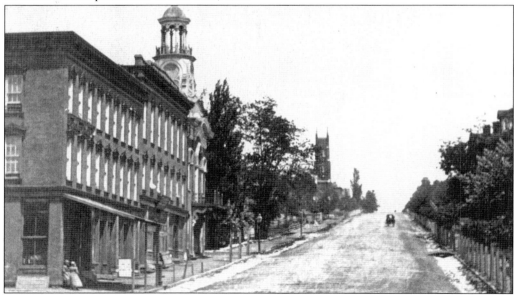

Looking north up Brady Street from Fifth Street shows the Odd Fellows Hall (immediate left, 508 Brady Street), John Cameron and Son Painters, and city hall. The Davenport Central Street Railway tested its first electric streetcar on this hill in 1888, and it easily carried a capacity carload of passengers up the steep grade. At that time there was only one other electric car system operating in the entire country.

In 1867, surveyors began their work to move the first bridge to span the Mississippi to its present location near the western end of the Rock Island Arsenal. Construction soon began on the new double-deck rail and wagon bridge with a $500,000 appropriation from the United States Congress. This first Government Bridge is pictured above shortly after completion.

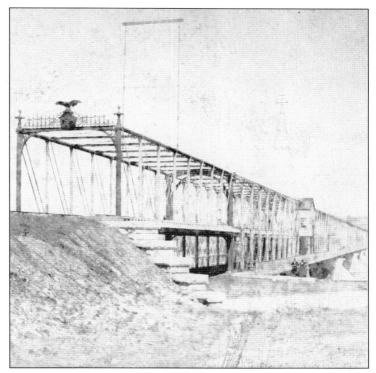

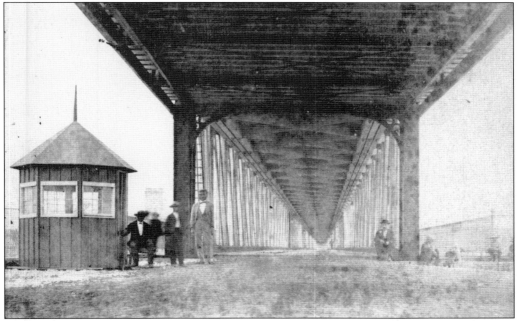

The first Government Bridge was opened in 1872, but on October 27, 1881, the *Jennie Gilchrist* stern-wheeler steamboat hit the bridge, losing the lives of 10 of her 15 passengers. In December 1895, work was started to tear down the bridge, and falsework was erected so train travel could continue while a new bridge was being constructed.

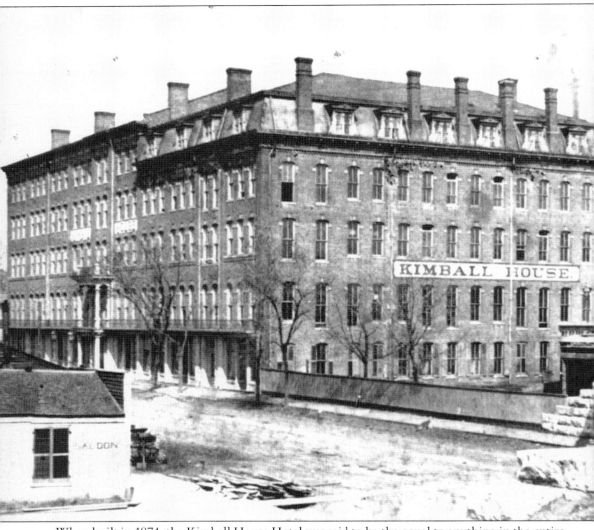

When built in 1874, the Kimball House Hotel was said to be the equal to anything in the entire West. It was strategically built with an entrance on the main line of the Rock Island Railroad. This photograph was taken from the railroad viaduct looking northwest from Fourth and Rock Island Streets (now Pershing Avenue). Originally called the Burtis House, its name was changed to the Kimball House in honor of A. A. Kimball, superintendent of the Rock Island Railroad (perhaps in gratitude of the train stopping at the hotel front door). The trains were certainly a blessing to all, but by 1876, it was stated that Davenport was being overrun by tramps that hopped the trains from the east.

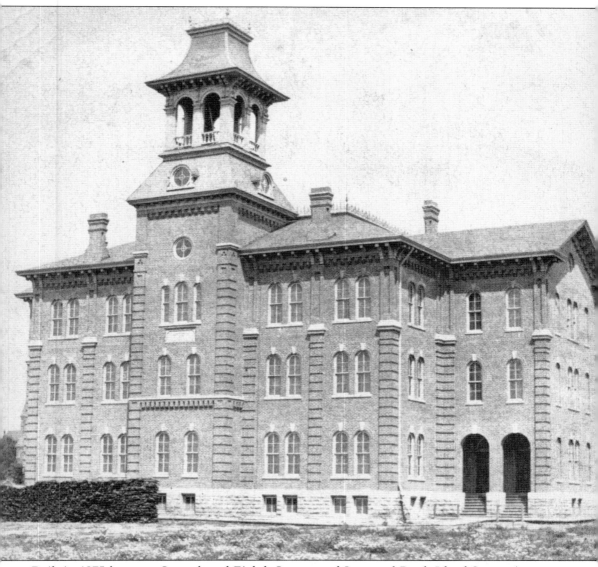

Built in 1875 between Seventh and Eighth Streets, and Iowa and Rock Island Streets (now Pershing Avenue), this was the very first building in Davenport constructed specifically as a high school. Among its graduates were Pulitzer Prize–winning author Susan Glaspell in the class of 1894. The principal was John B. Young, and it remained as the Davenport High School until the opening of the new high school currently known as Central High School in 1907. After the new high school opened, this building was used as an elementary school, and the name was changed to Lincoln School. In 1940, it was replaced with a new Lincoln School, which continues to serve as such today.

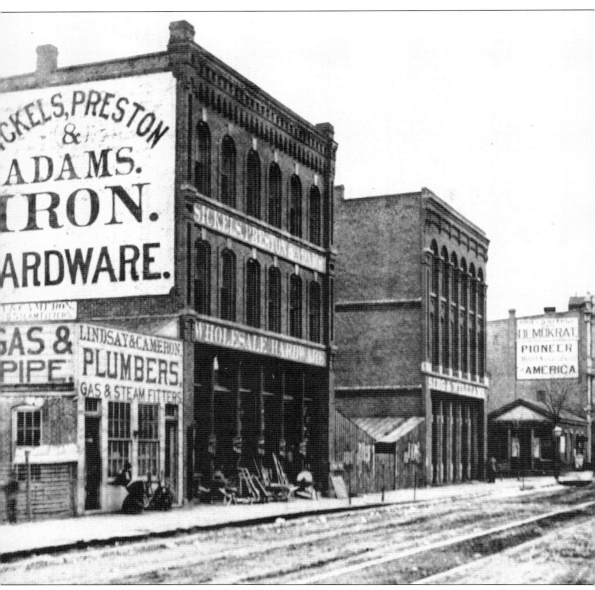

Streets were first macadamized (surfaced with crushed limestone) in Davenport in 1856. By 1858, at least two miles had been macadamized (Front, Second, and Third Streets) and 13 miles of wooden sidewalks were completed. In 1875, a city poll tax required every able-bodied man between 21 and 50 years of age to perform two days work on city streets or alleys between April and September. However, the obligation could also be fulfilled by paying $1.50 per day. In this view, from around 1877, the south side of Third Street between Brady and Main Streets is shown. Pictured here are the businesses of Lindsay and Cameron Plumbers, Gas and Steam Fitters (111 West Third Street), Sickels, Preston and Adams Wholesale Hardware Dealers, and the Sieg and Williams Hardware and Wagon Stock Dealers. City directories in those days often used general descriptors for business locations such as "southeast corner of Third and Main" rather than specific street addresses. The earliest directories were even more primitive, identifying a location as, for example, "three doors west of Brady on Third" or simply "Third west of Brady."

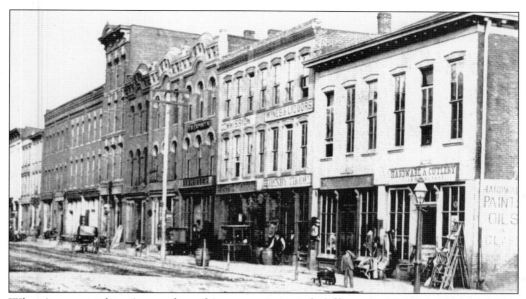

When it came to shopping, perhaps things were not much different in 1877 than they are today. In this short, one-block area on the south side of West Second Street between Harrison and Ripley Streets there were five saloons, three restaurants, three clothing stores, two billiard halls, two hardware and implement dealers, a watchmaker, a furniture dealer, a hotel, and a school.

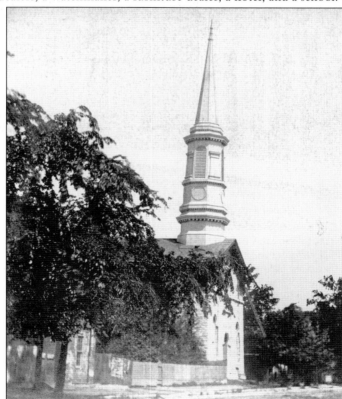

The Second Baptist Church stood on the southwest corner of Perry and Fourth Streets by 1856. Sabbath school was held at the church at 9:00 a.m. and again at 1:30 p.m. at widow Ann Jones's house on Scott Street, north of Third Street. In 1892, the post office was built on this site and was the first federal building in Davenport.

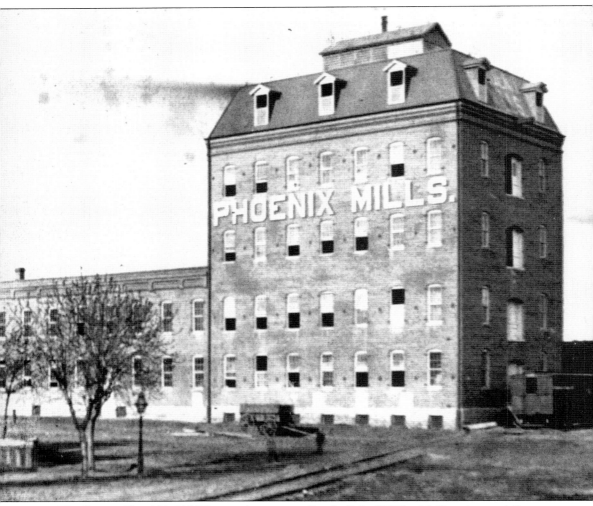

The flour mill at 101–113 Western Avenue was first built in 1862 by M. Donahue and Company. After changing hands several times, it burned down in 1879, was rebuilt, and was then purchased in 1880 by the Phoenix Mills Company. At that time, the nation was experiencing prosperity, and more buildings had been constructed in Davenport in 1880 than in any previous two years combined, with an aggregate cost in excess of $100,000. Sawmills and agricultural businesses were especially enjoying profitable times and expansion. Farming was still the most common means of living, and the city produced 100,000 barrels of flour that year with sales of $512,500. On the morning of September 26, 1881, the Phoenix Mill was struck by lightning, and the main building and all the milling machinery were destroyed. It was subsequently rebuilt and continued operation into the 1920s.

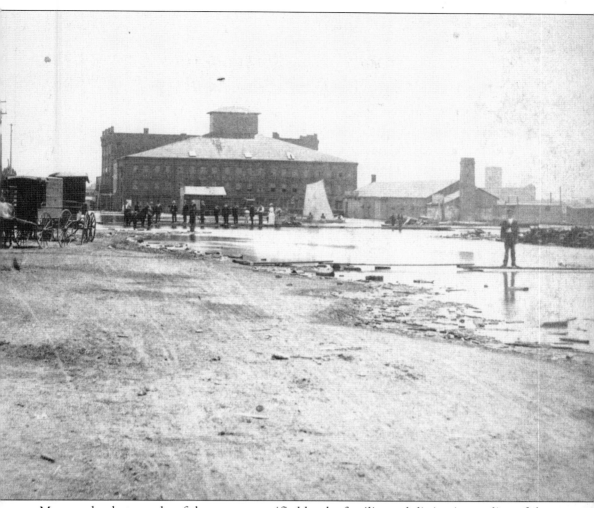

Many early photographs of the area are verified by the familiar and distinctive outline of the Arsenal Clock Tower in the far right background. Above is a view of the flood taken on June 26, 1880, in Davenport along Front Street (now River Drive) at the foot of Brady Street looking east. The ferry landing was at the foot of Brady Street, just out of view to the right. Wood planks were laid down to afford a dry walk from the ferry to Front Street. The tracks of the Chicago, Milwaukee and St. Paul Railroad ran along the levee and were completely underwater. The river played an integral part in the lives of citizens in varied ways. In 1880, municipal cleansing of garbage and ashes was accomplished under contract by dumping it directly into the river at an annual cost to the city of $500.

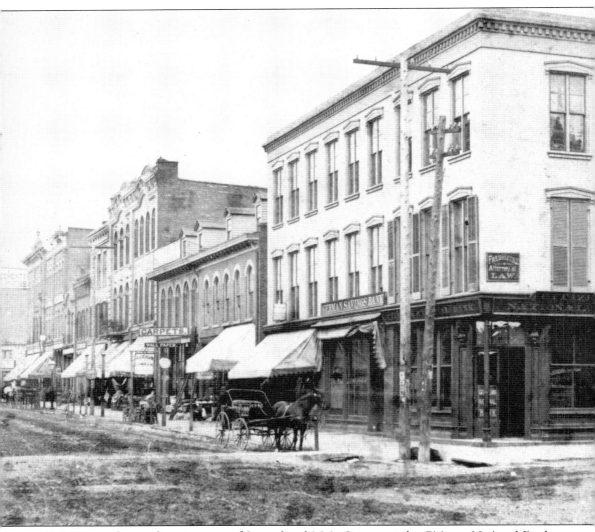

In 1880, on the northwest corner of Second and Main Streets sat the Citizens National Bank, and next door, the German Savings Bank. Across the street, on the southwest corner, was the First National Bank, as well as the Davenport Savings Bank. The only other bank in town was two blocks away at Third and Brady Streets. By 1900, the German Savings Bank was the largest of nine banks in Davenport. Anti-German sentiment of World War I, however, dictated a name change to the American Commercial Savings Bank in 1918 to vanquish frequent splashings of yellow paint. Similarly, on September 7, 1918, *Der Demokrat*, the oldest German newspaper in Iowa, announced that it would suspend operations entirely. It had been a loyal supporter of the government since the start of the war, but as Fred A. Lischer, the publisher, announced, a prejudice had developed that made it advisable to abandon the paper. Also of interest, situated at 220 West Second Street, was the drugstore of Edward and Gustavus Schlegel, the first in what would someday be a chain of many Schlegel Drugs.

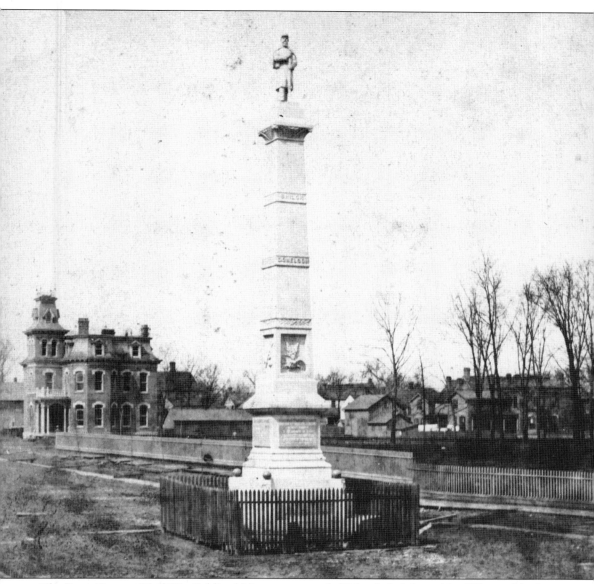

The Scott County Civil War Soldiers' Monument stands 50 feet in height and is still located in the middle of Main Street just north of Eleventh Street. Dedicated on July 4, 1881, it was engraved by a local man, W. W. Wallace, whose business was located at 217 West Third Street. In this early image, the Griswold College campus was located to the left, today the site of Davenport Central High School, and in fact, the land that the monument is erected on was donated by the trustees of the college. The large home in the background today is the Sigma Phi Chi Sorority of Palmer College (130 West Twelfth Street). Unfortunately, the fourth-story cupola has long since been removed.

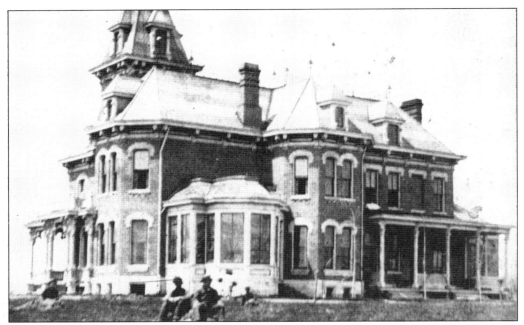

This 38-room home at 1208 Main Street was built from 1881 to 1884 for Davenport financier and capitalist James Monroe Parker. However, when Parker went bankrupt in 1893, the home was purchased by attorney, loan agent, and Davenport mayor Charles A. Ficke, who occupied it for about 40 years. In 1978, it was sold to the Delta Sigma Chi fraternity of Palmer School of Chiropractic, which continues to occupy and maintain it today.

Before the automobile, horses were kept for transportation purposes, and barns like the one shown above were a necessity. This home at 1426 Brady Street was the residence of William S. Chenoweth, who was a special agent for the Aetna Fire Insurance Company. It was purchased in the early 1900s by Frank A. Free, who raised his family here, and it became the well-known location of the "Free Photographic Studio."

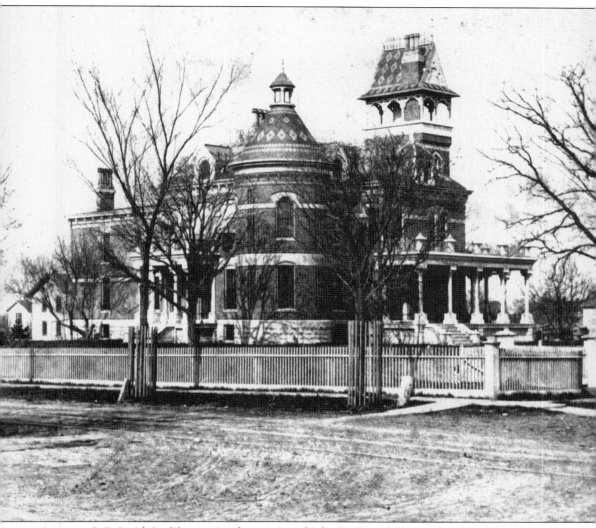

Attorney S. F. Smith Jr., like previously mentioned John H. Berryhill, was also the vice president of the Davenport National Bank when he lived in this stately mansion in 1886 on the northeast corner of Locust and Brady Streets. His father, Samuel Francis Smith Sr., was known for penning the words to "America," which served as the national anthem for much of the 19th century. S. F. Smith Jr., however, became infamous for fraud and embezzlement when he was convicted of stealing over $100,000 from local trust accounts he handled for the Oakdale Cemetery, the Lady's Relief Society, and other individuals and organizations. After his conviction, he was sent to jail, serving five years—only to die two days after his release. His home was removed to make way for the building of Madison Elementary School, which opened in 1940.

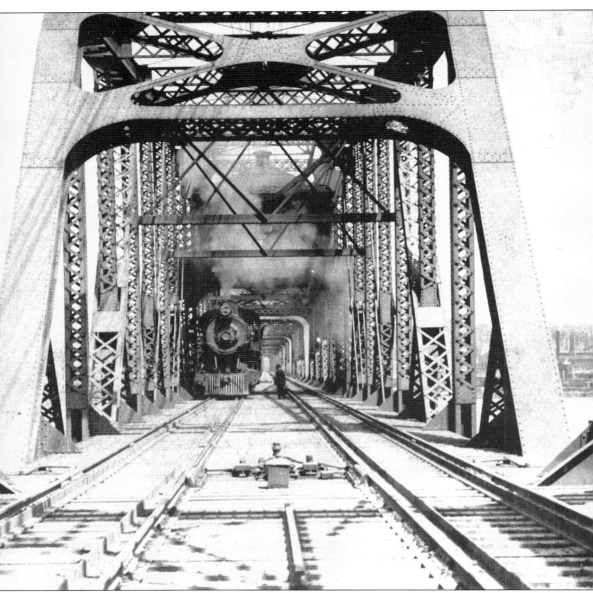

The new steel Government Bridge was built by the Phoenix Bridge Company and carried a double track above and a wagonway below; it also had electric lights and a compressed air draw. On February 25, 1896, before the bridge was completed, an ice gorge carried away the falsework and other bridge material of the old and also part of the new bridge under construction. In December 1896, work was finally completed, and this bridge continues in operation today, connecting the Rock Island Arsenal to the city of Davenport. Completed at the same site as the earlier bridge, it rests on the piers of that original wooden structure of 1872. Louis Wiese, of the firm F. Wiese and Sons Livery Stable of Davenport, had the honor of driving the first buggy across the new bridge.

Two

A Bird's-Eye View

Many of the city's leading merchants and businessmen built large homes of luxury on the bluff overlooking Davenport. These promontories could provide peaceful, spectacular, and inspiring views of the Mississippi River valley, including the Tri-Cities area (Davenport, Rock Island, and Moline).

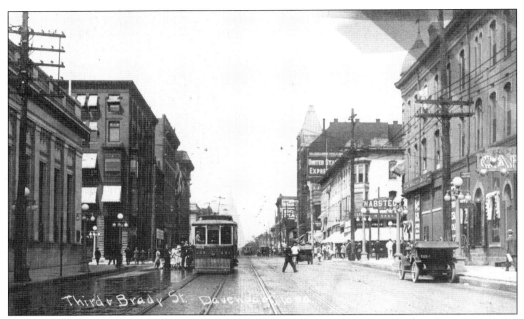

A line of people board the streetcar in front of the Union Savings Bank (southeast corner of Third and Brady Streets). A streetcar workers strike in 1919 caused a boom in the jitney bus industry, and on May 6, 1925, the Tri-City Railway Company petitioned the Davenport city council for the right to substitute buses for the electric cars on certain lines. This signaled the beginning of the end of streetcars in Davenport.

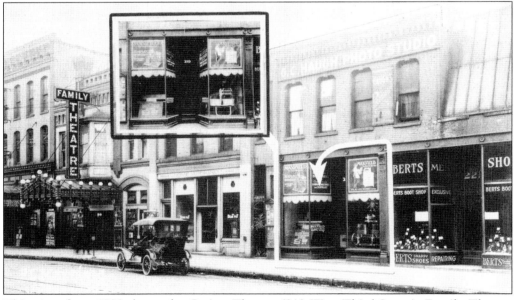

This view from 1920 shows the Casino Theatre (213 West Third Street), Family Theatre (215 West Third), the Bean Pot (217 West Third Street), Granville C. Haugh Photograph Studio (219½ West Third Street), F. L. Maxfield "the Wash Machine Man" (219 West Third Street), and Berts Shoe and Boot Shop (221 West Third Street). At that time, there were 18 moving picture theaters in town, including 6 within walking distance on Third Street alone.

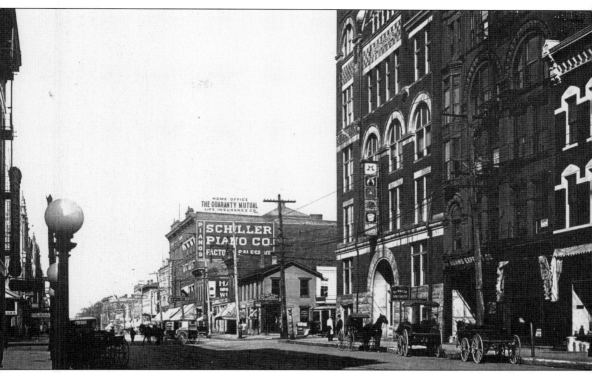

Businesses on the south side of Third Street included People's Gas and Electricity (125 West Third Street) and the Family Theatre (215 West Third Street). On the north side were Adams Express Company (124 West Third Street); the Masonic temple (Third Street, northeast corner of Main Street); Phil Daum, lawyer and justice of the peace (Third Street, northwest corner of Main Street); Schiller Piano Company (216 West Third Street); the Oppel Spencer Furniture Company (224 West Third Street); and the American Theatre (324 West Third Street). A horse-drawn dairy wagon can be seen in the intersection, and a sign in the window at Adams Express reads, "Baseball Today." Always a leading city of progress, Davenport streets had been lit with electricity since 1885. Local citizens had gotten their first glimpse of electric light in September 1879 when it was brought to town by the Great London Circus. The carbon arc–type lamps were operated by a 35-horsepower engine. Less than two years later, in 1881, electric lights were the evening's feature attraction at a ball sponsored by the Davenport Turner Society.

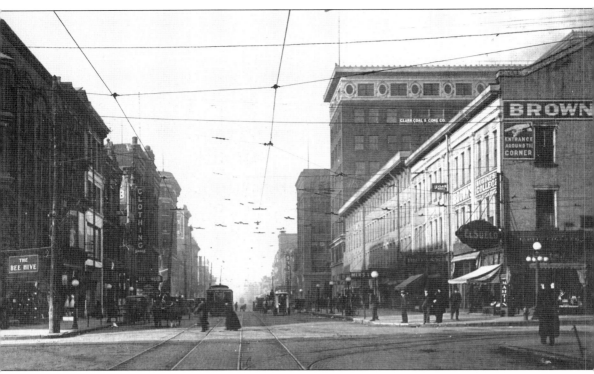

This famous corner was where physician Daniel D. Palmer first resided with his family and began his practice as a magnetic healer before discovering chiropractics. An advertisement in the 1889 city directory stated that he occupied rooms 7, 11, 12, and 13 in the Ryan Block (the building on the corner at the left). The Bee Hive, which furnished the latest in ladies apparel, was also located in that building on the first floor, although not at the same time. Brown's Business College and Martin's Cigar Store No. 1 sat on the opposite corner in the old North Putnam Building. In 1912, about the time this photograph was taken, a person dialed the number 4 if they wanted to place a telephone call to Martin's Cigar Store. On April 11, 1921, the governor of Iowa finally made it legal to sell cigarettes to adults, even though smoking them had become popular by the end of World War I.

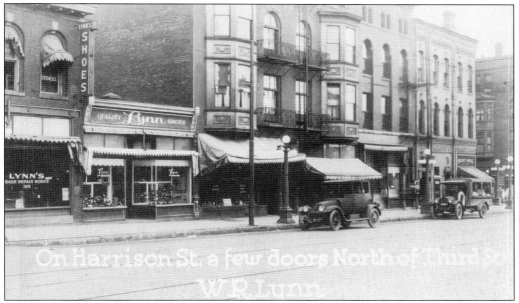

A 1920 postal advertisement for William R. Lynn Shoe Store (313–315 Harrison Street) also pictures the Savoy Café (309 Harrison Street), Lee R. Wareham Billiards (307 Harrison Street), and Hickey Brothers Cigar Store No. 6 (on the corner). Automobiles at that time were still considered transportation for the wealthy, and the most popular method of travel was by streetcar, reaching maximum usage about 1923 and steadily declining after that as automobiles became more affordable to the middle class.

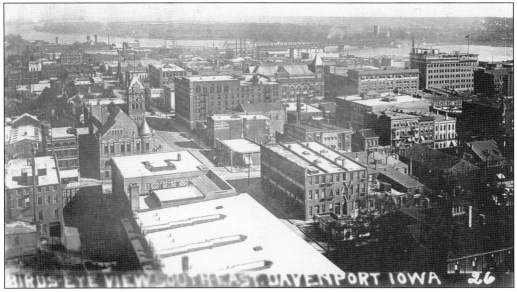

This bird's-eye view was taken high atop the Scott County courthouse around 1910. In the lower right corner is Harrison School (325 West Fourth Street), and east of that on Fourth and Harrison Streets is the Peter Jacobson Cigar Factory (301–311). In the distance (upper right), on the northeast corner of Second and Main Streets, can be seen the construction of the Putnam Building, Davenport's first real skyscraper.

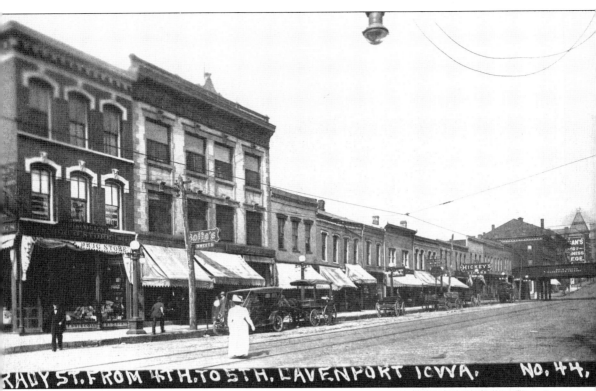

RADY ST. FROM 4TH. TO 5TH. DAVENPORT IOWA, NO. 44,

The sign above Jeremiah E. Driscoll's Drug Store (402 Brady Street) reads, "Specialist for Diseases of Men." Other businesses on the west side of Brady Street included William C. Bolte's Confectionery (404); Dr. Logan Dodds, dentist; Edmund M. White Books and Stationery (406); Daley's Lunch Room; M. P. Meyer Market; John Poeltl Furniture (420); Hickey's Cigar Store No. 2 (424), and Duncan's Davenport Business College. Just west of the train overpass sat the Rock Island Passenger Station. The streetcars were powered by electric motors that received power from the overhead lines and of course traveled on imbedded tracks in the street, which impeded the flow of all other forms of traffic to some degree, especially bicycles. The maze of wires and miles of tracks would all be removed when city buses proved to be a logical replacement and improvement to streetcar transit. Motorman Charles Shellhorn drove the very first electric streetcar up this hill on August 17, 1888, and had the similarly historic honor of being the motorman of the last run made across the Government Bridge on April 16, 1940.

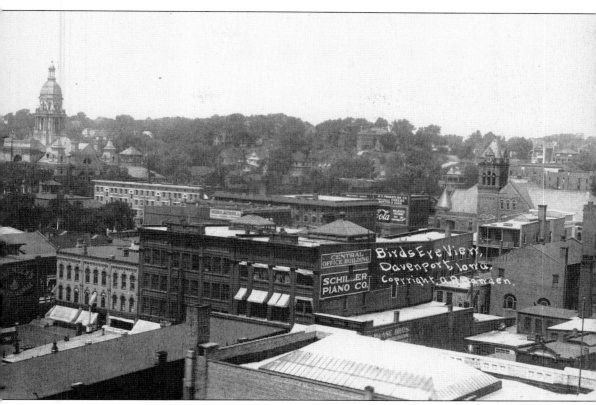

Overlooking West Third Street around 1913, Lorenzen's Crockery Company "China & Glass Ware" (225 West Third Street), Berg Brothers Sporting Goods (230), Spencer Furniture Company (224), and Schiller Piano Company (216) can all be seen. Behind these businesses, one block away, is city hall (Fourth and Harrison Streets), as well as the ubiquitous soda sign reading, "Coca Cola Relieves Fatigue 5 Cents." In 1903, Peter N. Jacobsen moved his father's old cigar-manufacturing business into the former U. N. Planing Mill at Fourth and Harrison Streets, kitty-corner from city hall. A popular employer, in 1917, he instituted pension plans for both old age and disability at his factory. The tall, dome-topped building in the upper left corner was the Scott County courthouse, which sat in the same location as the present building. The courthouse had construction issues throughout its life. It had started settling and sinking even before it was completed. The tower was condemned in 1923, repaired, condemned a second time in 1933, and finally removed from the rest of the building. Removing the tower lightened the structure by over 1.6 million pounds.

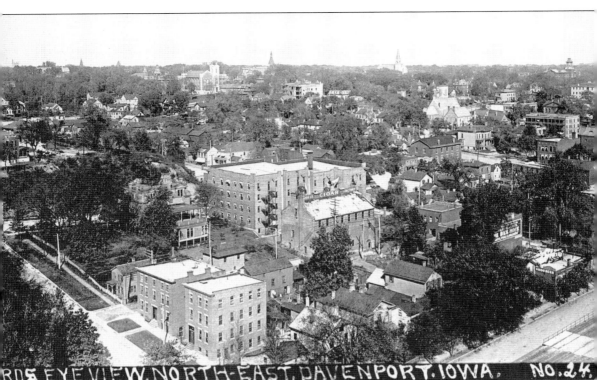

The back open porch of the Matthias Frahm Residence (321 West Sixth Street) can be found just left of center in this view. In 1850, Frahm began building Davenport's first and subsequently one of its largest breweries, the City Brewery, which was located just east of his home on Harrison Street between Fifth and Sixth Streets. He had pipes installed that ran from the brewery directly into his home to supply beer on tap at all times. The brewery itself was removed and replaced by the large apartment building known as Roosevelt Flats, which is seen above in the center and is still in use today.

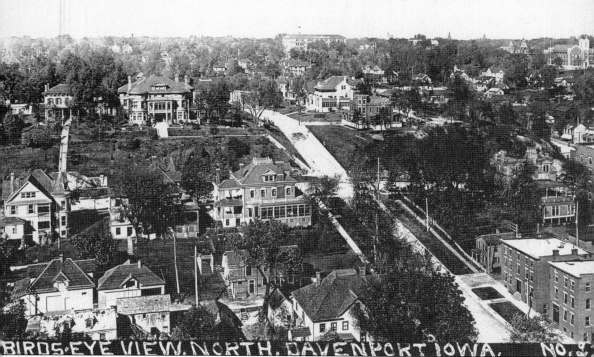

BIRDS·EYE·VIEW·NORTH·DAVENPORT·IOWA. NO. 3

This view, looking north from the courthouse over Ripley Street hill, features some of Davenport's most beautiful homes, with large carriage houses, long stairways winding up their well-manicured terraces, and classic 19th-century architecture. Perhaps most prominent is the residence of August E. Steffen, at the top of the hill left of center. His home, located at 410 West Sixth Street, was named Overview. The home of Henry Struck at the top of the hill (center of photograph, 703 Ripley Street) was of the Queen Anne Revival style and featured distinctive dual corner towers and gables. Originally located on the south side of West Fifth Street, the house was moved soon after its construction to make room for the railroad. The mansion was brought to its present location by being drawn by horses up the steep Ripley Street hill.

47

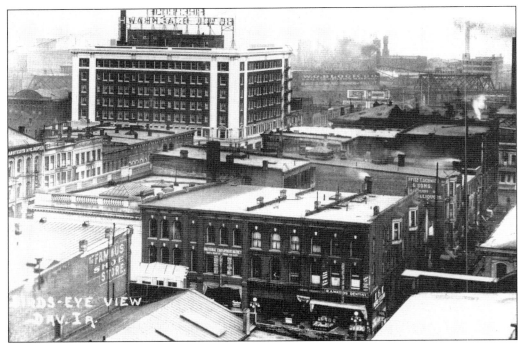

This aerial view in 1915 overlooks Brady Street, north of Second Street. The I&I News Stand at 217 Brady Street is prominently in view with the Famous Shoe Store, 222 Brady Street, across the street. The recently constructed seven-story Hotel Blackhawk (Perry and Third Streets) displays a huge neon sign reading, "Fireproof Hotel Blackhawk." In 1920, it became the largest hotel in Iowa when four additional stories were added to it.

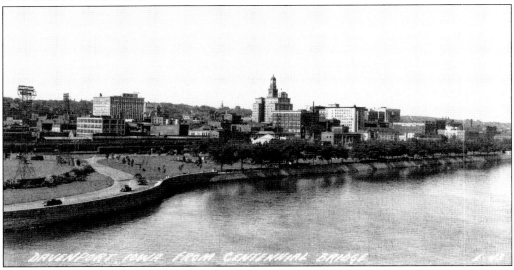

Completed in July 1940, the Rock Island Centennial Bridge provided the perfect spot for taking scenic photographs overlooking Municipal Stadium and Antoine LeClaire Park. The Peterson Memorial Music Pavilion had been erected in 1924. The tallest building downtown is the Davenport Bank at 220 Main Street, which has a three-story cavernous banking room and a massive clock tower and, at that time, housed Hickey Brothers Cigar Store No. 20 in its lobby.

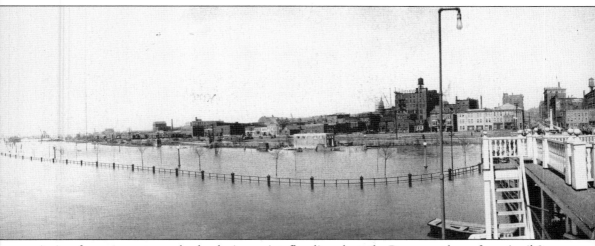

A view from atop a steamwheeler during spring flooding along the Davenport levee from April 9, 1920, shows the steamboat landing on the right in the foreground. Both Petersen's Sons' (on right) and Harned and Von Maur's department stores (center) can be seen in the background on Second Street (note the large water towers on both rooftops). The buildings were so tall that they exceeded the height that the city's water pressure could handle and solved their own water pressure problems by having their own pumps and rooftop holding tanks. On First Street, beginning on the far right, are the Harrison Hotel (128 West First Street), St. James Hotel (202–212), Martin Cigar Company Commissary (214), Lend-A-Hand Club Annex (216), the home of machinist Harry Osgood (220), Merchants Transfer and Storage Warehouse (222–224), Witt Bottling Works (300–316), and the Tri-City Fuel Company Barn (316). In the mid-1880s, the St. James Hotel ranked second to none as a $2 per day house.

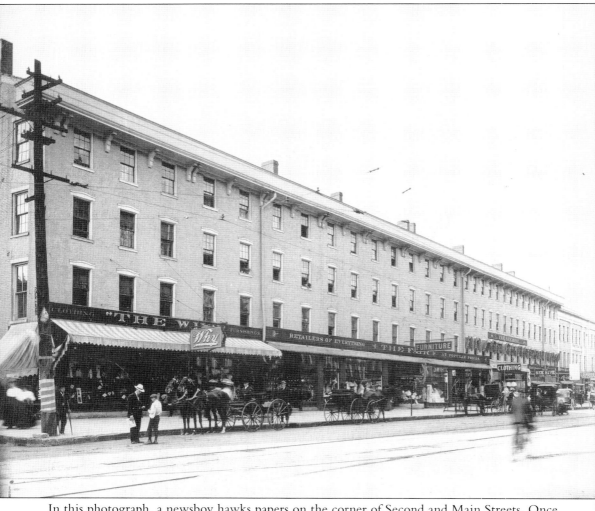

In this photograph, a newsboy hawks papers on the corner of Second and Main Streets. Once known as LeClaire Row, and later the Viele Block, businesses here included the Why Clothing House (northeast corner of Main Street, 130 West Second Street); the Fair Five and Ten Cent Store, "Retailers of Everything at Popular Prices" (120–124); the Bee Hive Cloak and Millinery (114–116); "Frank Maehr Baker, Confectioner, and Ice Cream" (110); Esek S. Ballard Druggist (106); Brown's Business College; and Martin's Cigar Store. E. S. Ballard also served as the president of the Davenport National Bank. The Putnam Building now occupies this corner. The Fair Store changed its name and moved into a new seven-story building on the far end of this block in 1922 as the M. L. Parker Department Store. The $1 million building featured more retail floor space than any other store in Iowa.

Three

AT HOME WITH
THE FAMILY

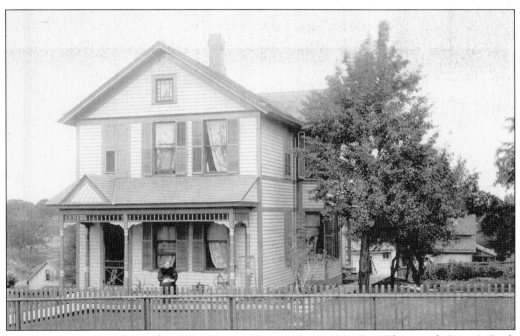

The home above was located at 1804 Summit Avenue (now 1804 East Thirteenth Street). Back in 1875, any dog running loose within city limits without a muzzle was to be shot on sight by the city marshall. Geese, hogs, horses, mares, mules, and cows were not allowed to run free in the city either. The owner of the violating animal could be fined $5. Other misdemeanors included playing ball on any city street or alley, leaving a team of horses on a footpath crossing a street, bathing in the Mississippi River, and hitching a horse to a tree in a public park.

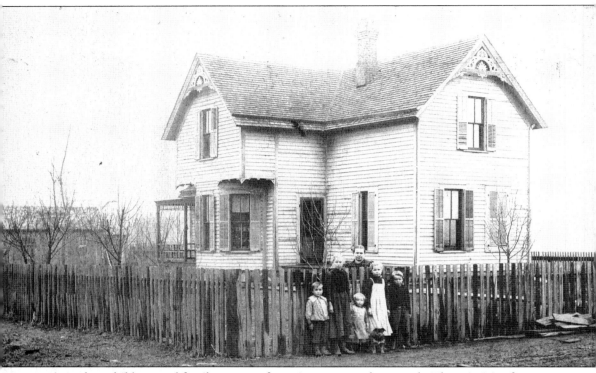

A mother, children, and family pet pose for an impromptu photograph. The primitive fence was functional if not attractive. In 1880, nearly all the houses in the city depended on privy vaults for human excreta. The only regulation concerning the construction of vaults was that they must be at least 20 feet from any well or spring used for drinking water. The vaults were cleaned out at least once a year by regular night scavengers with covered watertight carts, and the contents were dumped into the river two miles downstream of the city.

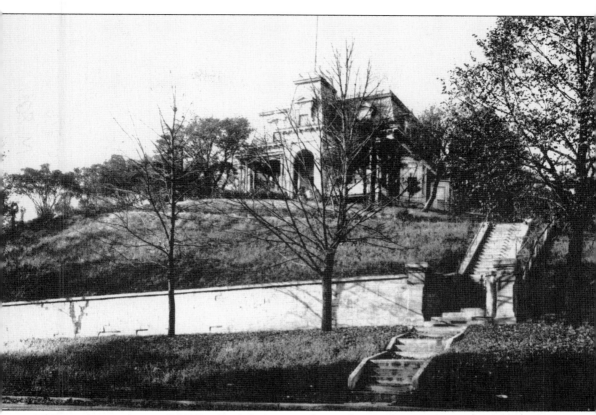

This stately mansion at 608 West Sixth Street was the residence of Otto Klug, one of the area's most esteemed citizens. He immigrated to Davenport in 1849 and opened a general merchandise store on Front Street that he ran until 1870 when he went into the commission business. Later in life he tended to his farms, vineyards, and considerable city property that he owned. He also held the offices of city treasurer, alderman, and school board member over his lifetime. By the 1920s, the home was occupied by his spinster daughter Lillie, and it was converted to apartments in the early 1960s. It was heavily damaged by fire in November 1967 and finally razed in January 1968.

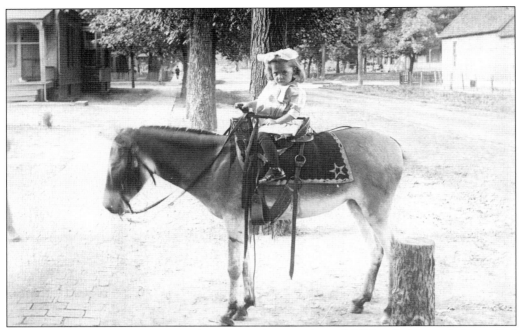

In the early 1900s, it was quite popular to have pictures taken of children being carried or pulled in carts by animals such as donkeys, horses, and goats. Photographers would actually bring the animals with apparatus around with them to stimulate sales. This little girl poses on a mule near the 1500 block of West Seventh Street.

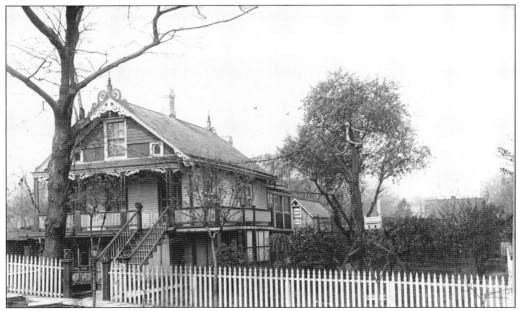

This very unique home was located at 556 College Avenue. Gingerbread trim work and white picket fences were a popular sign of American success. The owner, Mr. Young, apparently delighted in making a playground for the squirrels. The tree to the right of the home contains a large antler, a birdhouse, several ladders, and various boards running from the tree to his home.

The front porch was an important part of any home and served as a gathering spot and a place to furnish a friendly wave and "how-do" to passing neighbors. The old traditions of visiting on Sundays, attending theatrical performances, dancing, playing cards, and drinking beer were brought to Davenport by immigrant Germans in the late 1840s. In 1914, 90 percent of all Scott County land was owned by people of German descent.

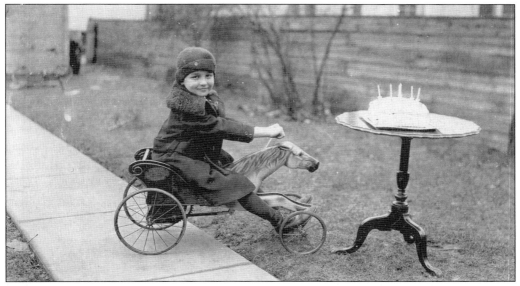

A Davenport lass poses on her "Dan Patch Racer" with her birthday cake on the family's best table in the backyard on her sixth birthday.

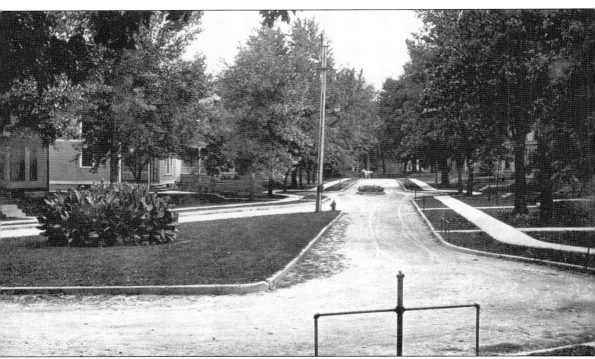

The unmistakable layout of Walling Court shows macadamized streets and the hitching post in front of Emil Berg's residence in 1911. From 1901 until her death in 1922, Phebe Sudlow lived at 1930 Walling Court, just a few houses away to the right. Sudlow had the distinction of becoming the first female school principal in the entire United States. The unique boulevards of Walling and Arlington Courts were actually under the care of the Davenport Park Commission. The total cost to the city for the care of these two courts for the first 18 years (1890–1908), including plants, shrubs, and maintenance, was $145.48.

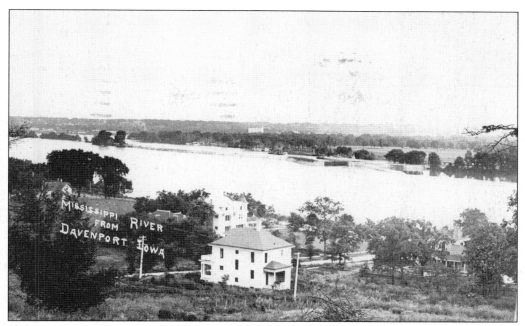

This view was taken near the Davenport and Bettendorf border in 1910. The house in the foreground still stands at 108 Greenwood Avenue. The large home behind it is today the McGinnis Chambers Funeral Home on River Drive. In 1904, the state of Iowa ranked third in the nation behind Texas and Missouri in miles of public roads. At that time, however, more than 98 percent of them were still just dirt, and often mud.

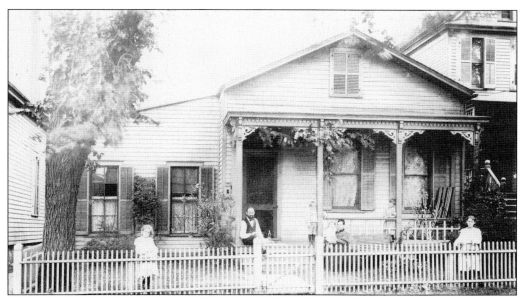

This postcard of the home of Theodore and Antonia Folk of 918 West Sixth Street was discovered in Germany. The couple had immigrated to Davenport in 1880 from Kiel, Germany, and likely sent this photograph back home to relatives. Theodore worked as a traveling salesman and later a travel agent, while his wife was a teacher in the German Free School.

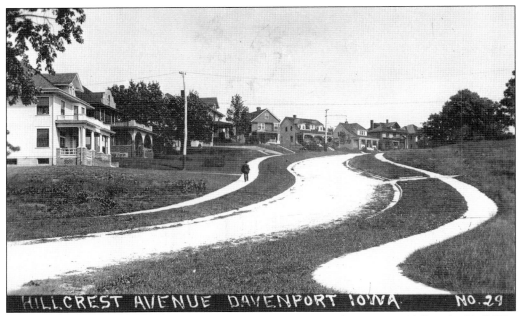

Hillcrest Avenue was cut through the area previously part of Camp McClellan (a Civil War training grounds). Today this is just north of Lindsay Park in the village of East Davenport. The first two houses on the left are 26 and 30 Hillcrest Avenue and were owned by merchandise broker W. J. Houseman and Gustav C. Lerch, respectively. Lerch owned a shelf hardware, tinware, and sheet metal business.

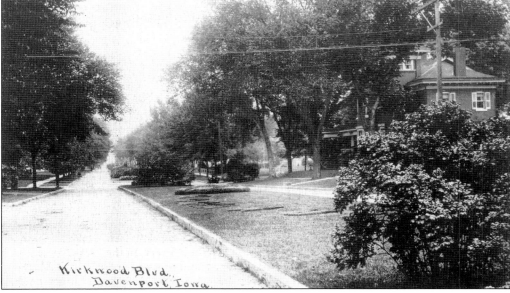

Davenport was known far and wide as the "City Beautiful," and Kirkwood Boulevard ran among the most attractive neighborhoods in town. Beginning in 1894, the city parks commission supplied flowers and shrubs and maintained the expansive boulevard throughout the growing season. Originally the boulevard was envisioned to run from Lindsey Park on the east to Fejervary Park on the west, but the extension west of Brady Street never materialized.

Four

SERVING THE PEOPLE

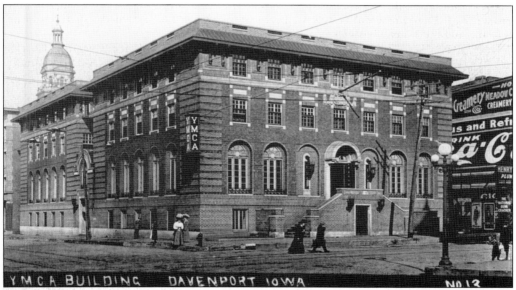

YMCA BUILDING DAVENPORT IOWA NO 12

The YMCA building was completed in 1909 at 404 Harrison Street. In the 1930s, student Jack O'Mahoney would walk there almost every day after school to swim and play basketball and then make the six-block walk home to 436 West Eighth Street. He became an outstanding athlete at Davenport High and then competed in swimming, basketball, and football for the University of Iowa Hawkeyes. Later known as "Jock" Mahoney, his athletic ability, physique, and good looks would lead him to Hollywood, where he played the role of Tarzan in several motion pictures and starred in the 78-episode television show *The Range Rider*. He was also stepfather to actress Sally Fields.

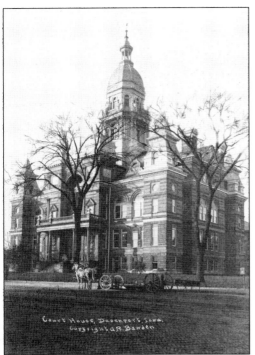

Construction was completed in 1889 on this, the second Scott County courthouse, at the same location as the original building built in 1842 on the northwest corner of Fourth and Scott Streets. Records provided in the first city directory of 1856 show that the total taxes collected for the year were $9,605.03, or about 75¢ per person. This courthouse was razed and replaced in 1955.

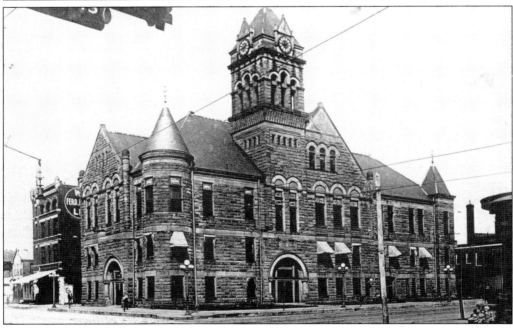

At 12:30 p.m., on September 14, 1896, the bell on Davenport City Hall rang out for the first time. It was said that city hall was built by the saloons and their tax money, as Davenport had 150 saloons, each paying $300 per year for the license to sell. Ferdinand Roddewig's Sons Wholesale Liquor business sat directly behind it at 409 Harrison Street and was often referred to as "City Hall Liquors."

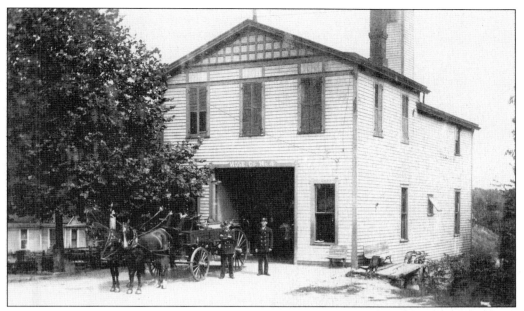

Hose Station No. 4 was located at 1502 Fulton Avenue (renamed East Twelfth Street). By 1920, the city fire department had become completely motorized with the most modern models. The National Board of Fire Underwriters awarded Davenport the best rating of all cities in the entire United States with the exception of Cleveland, Ohio.

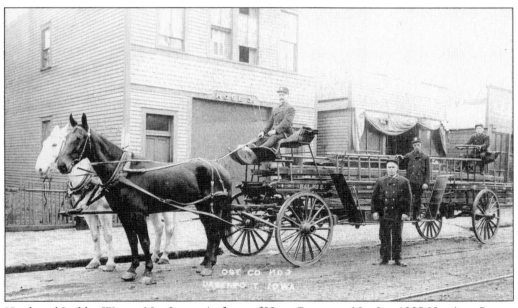

Hook and Ladder Wagon No. 2 stops in front of Hose Company No. 3 at 1225 Harrison Street. Ladders were carried for obvious reasons, but hooks had a variety of uses, including pulling boards and plaster down to expose and extinguish hidden flames. South of the firehouse were Steckel Brothers Plumbing and Heating and the C. E. Osborn Construction Company.

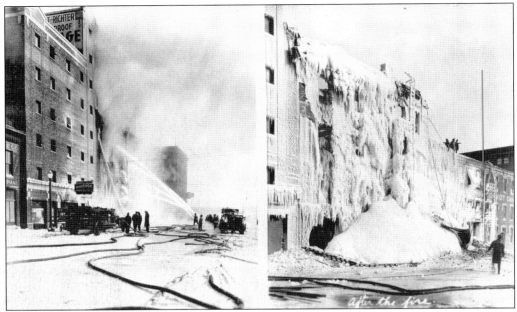

Fires during winter were especially dangerous and hard to fight, such as the famous fire of the Ewert and Richter Fireproof Storage building (316 East Fourth Street) on February 8, 1933. For three days, firemen braved freezing temperatures, biting wind, failed equipment, and the dangers of ice to fight both fire and frostbite.

$20 REWARD!

Stolen from me Sept. 22d, 1875, a light chestnut sorrel Mare, 16½ hands high, star and white stripe in face, front feet and right hind foot white nearly to the knees, small lump on inside of right hind leg about six inches above ankle joint; will pull at the halter sometimes, and in the hands of strangers *sometimes* balk; when first hitched to wagon, sometimes will pace a few rods, but at no other time. She is high on the withers, broad steep rump, free driver, and good traveler. The thief had a new halter with new bridle bit attached.

I will give the above reward for the recovery of the property.

Address,

HENRY PARMELE,
P. O. Box 878, DAVENPORT, IOWA.

Reward notices were sometimes sent to area sheriffs and constables to alert them of recent crimes, such as the horse theft above from 1875. In 1862, the two city policemen were paid a salary and fees according to the number of arrests made. In 1885, the city council adopted an eight-hour working day for all city employees, including policemen, and in 1888, regular police patrols were initiated.

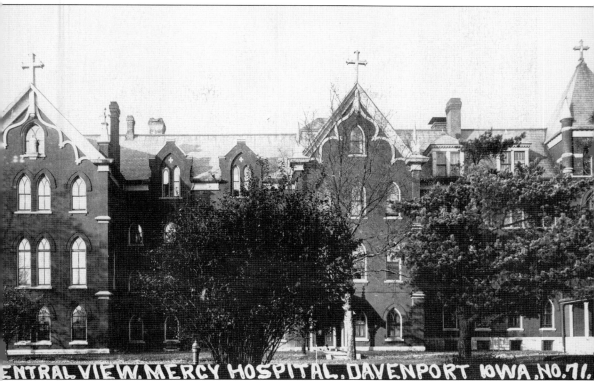

ENTRAL VIEW, MERCY HOSPITAL, DAVENPORT IOWA, NO. 71.

In 1869, Mercy Hospital was established as the first hospital in the state that was unconnected to a military need or a medical school. The two previous Iowa hospitals were used for instruction at the State University of Iowa and the care of soldiers during the Civil War. It was also only the third private hospital ever established west of the Mississippi River, following those founded in San Francisco and St. Louis. The building pictured above (around 1910) featured several additions to the 21-bed building that had originally served as the Immaculate Conception Academy (a select school for girls) but was abandoned in 1861 for a site nearer the center of town. Davenport reported nearly 300 cases of cholera in 1873 (over 100 resulting in death) due mostly to a poor water supply and generally unsanitary conditions. Mercy Hospital was the site of the first recorded appendectomy in the United States, when Dr. William Grant performed the operation on Mary Gartside on April 23, 1883.

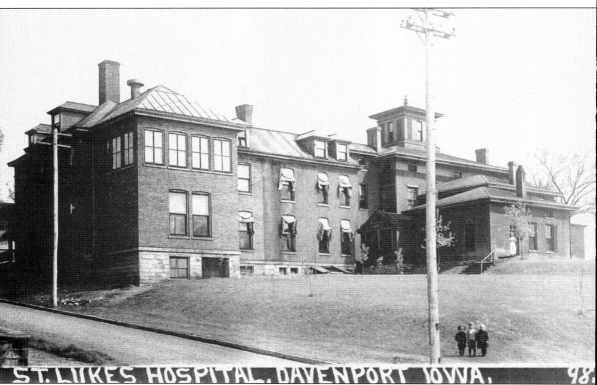

ST. LUKES HOSPITAL. DAVENPORT IOWA. 98.

St. Luke's Hospital opened in 1895 at 712 Brady Street, the former residence of Daniel and Patience Newcomb. Born in New York, Daniel Tobias Newcomb served in the War of 1812 and afterward settled in an area now named after him, Newcomb, New York. As an adventurous explorer of the Great West, he settled in Iowa, 15 miles downstream of Rock Island, bringing his family to his log cabin in 1837. He accumulated over 1,200 acres of land and amassed a vast fortune as one of the first farmers in Iowa to use agricultural machinery. Newcomb moved to Davenport in 1842 and built this home about that time. His wife, Patience, was philanthropic throughout her life, being active in the cause of wounded soldiers of the Civil War. The view of the hospital above is from about 1908. It is one of the oldest surviving buildings in Davenport, serving today as a 16-unit apartment. The hospital was moved to a new location at 1224 East High Street by 1920 and is the site of Genesis Medical Center East Campus today.

The grand Masonic temple was completed in 1888 on the northeast corner of Third and Main Streets at a cost of $68,000. The land alone cost $9,000. Besides furnishing facilities for Kaaba Temple on the fourth floor and the Masonic lodge on the fifth, various other businesses occupied rooms in 1920, including a contractor, barber, dentist, investment banker, mortgage broker, lawyers, physicians, and Ruhl and Ruhl Insurance and Real Estate.

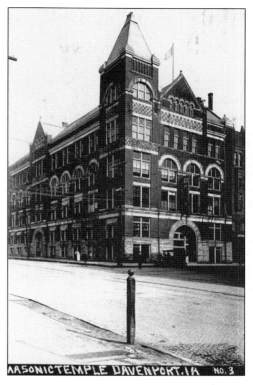

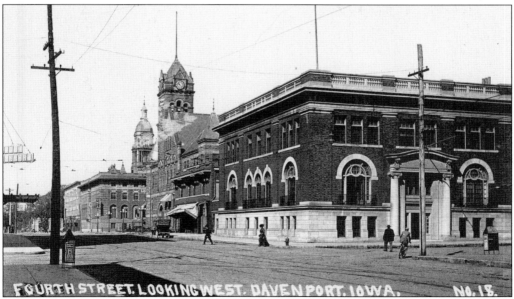

The Commercial Club, built in 1907, held the offices of the Davenport Chamber of Commerce and other local business organizations over the years and was located on the northwest corner of Fourth and Main Streets. In 1912, it welcomed ex-president of Princeton University and governor of New Jersey Woodrow Wilson as its guest speaker. He was welcomed back again in 1916 as president of the United States.

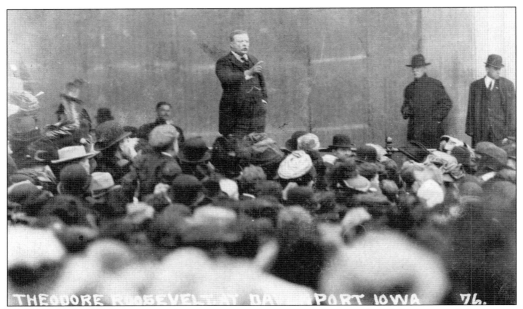

When Pres. Theodore Roosevelt visited Davenport in 1910, he was a breakfast guest of Davenport authoress Alice French, whose book *Stories From a Western Town* was one of his favorites. French wrote under the pseudonym Octave Thanet, and contemporary critics placed her at the head of American fiction writers. In 1900, a writing society was chartered at the State University of Iowa and named Ocatve Thanet in her honor.

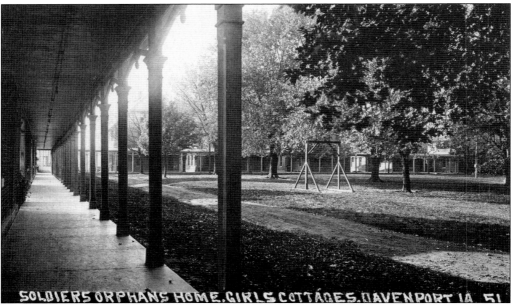

The Iowa (Civil War) Soldiers' Orphans Home was located northeast of the city via Grove Street. Today that remote location lies in the heart of town in the 2800 block of Eastern Avenue. Children were separated and housed in small cottages. Among the famous to have grown up here include professional baseball player and evangelist Billy Sunday and big band leader Wayne King. It was renamed the Annie Wittenmyer Home in 1949.

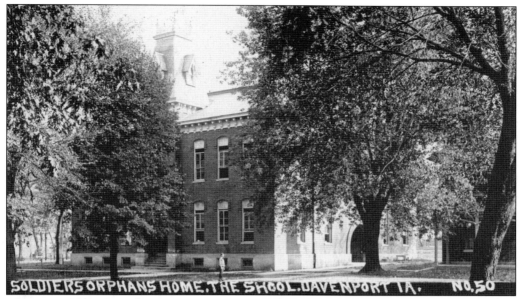

The Iowa Soldiers' Orphans Home was mostly self-sufficient, having a large farm to produce crops for the children and staff. The farm extended north of Duck Creek, all the way to Kimberly Road. When farming was finally discontinued, the barn was sold and converted to a flower and seed business, operating for many years under the name Kimberly Barn at 1221 East Kimberly Road, now the location of Cheddar's Restaurant.

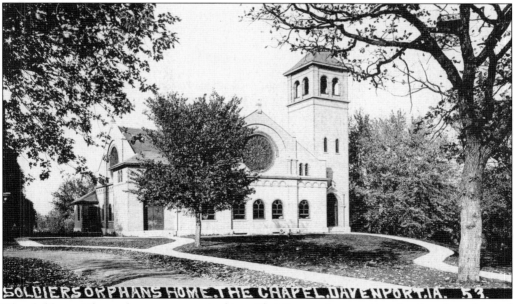

The children at the orphanage were raised in a Christian environment, and a chapel was located on the grounds. After the home was closed and sold to the city, the chapel was converted into a theater. Today the Mary Fluhrer Nighswander Junior Theatre hosts an audience of up to 440 and offers plays, recitals, movies, and other community events.

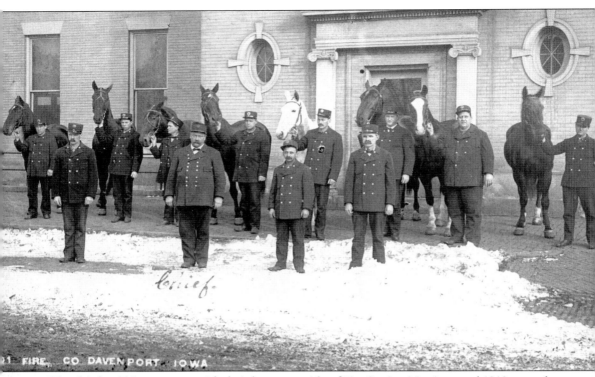

The chief and his men pose with their horses outside of Fire Station No. 1 around 1910, now the Central Fire Station (Scott and Fourth Streets). The very first structure fire in town occurred in 1845 to the building that had previously been the first store in town, opened by D. C. Eldridge in 1837. In the mid–1850s, fire protection was limited to the area from the river to Fourth Street between Ripley Street on the west and Rock Island Street (now Pershing Avenue) on the east. Within that district, by law, no wooden structure could be erected more than seven feet in height. In 1867, when a fire raced out of control in Camden (now Milan, Illinois), the firemen of Davenport, along with their steam fire pumper, were rushed by boat and then by train in an effort to help save the burning town. Davenport did not have paid firefighters until 1882.

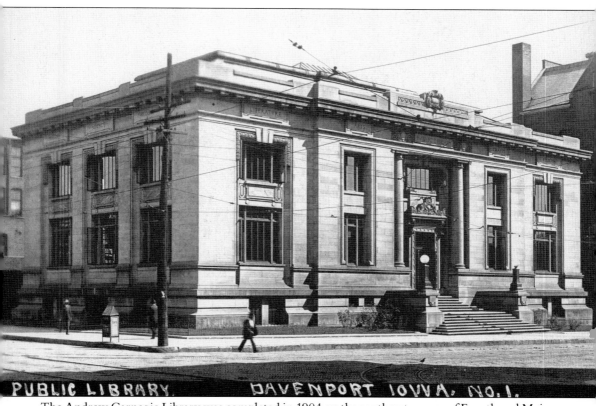

PUBLIC LIBRARY. DAVENPORT IOVVA, NO. 1.

The Andrew Carnegie Library was completed in 1904 on the southeast corner of Fourth and Main Streets. However, during the construction of a much-needed addition in 1963, the foundation was disturbed so badly that the walls began to crack and shift, and the instability of the library eventually made it necessary to abandon. The entire volume of books was transplanted to the former Hill's Department Store on the southeast corner of Second and Harrison Streets as a temporary library while a new one was built. Constructed at the same location, the current modern Main Library was dedicated and opened on October 6, 1968. The rubble of the above building was used to fill in the pool of the Lindsay Park Boat Club once located south of Lindsay Park and River Drive, where a boy had drowned in the mid-1960s.

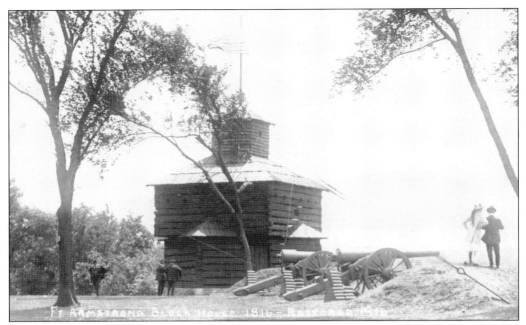

Fort Armstrong served the early settlers against Native American uprising from 1816 until about 1836. After it was torn down, some of the wood was used in making Storehouse A (the Clock Tower Building). Shown above is the exact replica blockhouse of the original fort, which was set on the southwest blockhouse site near the Government Bridge for the centennial celebration in 1916.

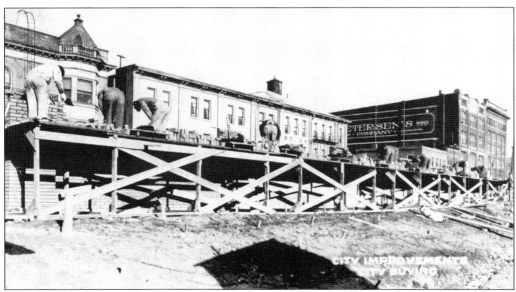

One of the city improvements in 1922 was the construction of the Municipal Natatorium, Davenport's only city swimming pool for many years. It was built at the corner of Main and Front Streets, and the postcard above shows the construction of its exterior wall. Across the street are the Lend-A-Hand, Martin Cigar Commissary, and St. James Hotel.

Five

SCHOOL DAYS

School No. 1 was located on the southeast corner of Fulton (now East Twelfth Street) and Mississippi Avenues, and Phebe W. Sudlow served briefly as principal in 1887. One of the students there, Eugene Ely, became the first person in history to fly an aircraft off of and onto a ship, proving that it could be done and providing legitimacy to the vision of the modern aircraft carrier. Later the name of the school was changed to Washington and has been replaced by the current Washington Elementary on Locust Street and Eastern Avenue, where the original schoolhouse bell from old School No. 1 is still on display on the front lawn.

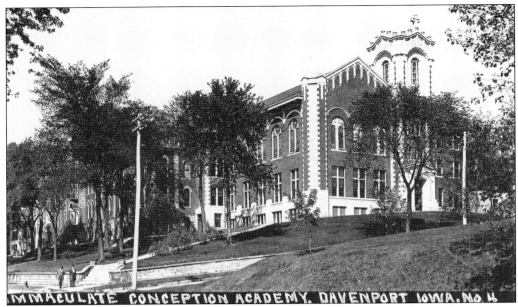

The Academy of the Immaculate Conception occupied this location on the northeast corner of Eighth and Main Streets since 1861. A boarding school for Catholic girls, it was conducted by the Sisters of Charity of the Blessed Virgin Mary. It merged with the St. Ambrose Academy (an all boys' school) in 1958 to form Assumption High School. The buildings shown above are now part of the campus of Palmer College.

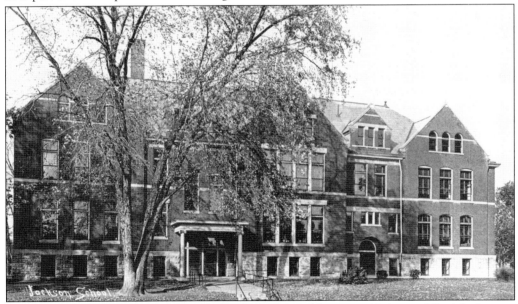

Originally called School No. 6, this school was located between Union and Prairie Streets, and Washington and Mitchell Streets (1420 West Sixteenth Street). Its name was changed to Jackson School in 1908 when numbered schools were named after their respective United States president. The school was sold and became Holy Family Catholic School in 1945 until its new building was built near its church in 1965.

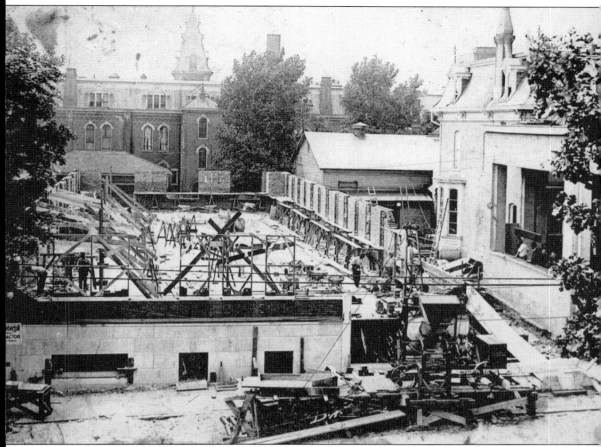

The developer of the chiropractic adjustment, B. J. Palmer built his chiropractic fountainhead in Davenport. Local citizens were not overwhelmingly convinced of the legitimacy of the profession, as pep talks and classes of salesmanship were normal fare at the school. Palmer School of Chiropractic was founded in 1897, and after 1900 ran advertisements in the local high school paper that read, "After High School – then what? Your father's office or your own office? An overcrowded business, a long dead profession, or a profession of to-morrow? Chiropractic is a professional business where brains and brawn are essential." Early building construction can be seen here on Brady Street, with the Immaculate Conception Academy behind. Palmer spent over $350,000 between 1920 and 1923 to erect new administrative and classroom buildings.

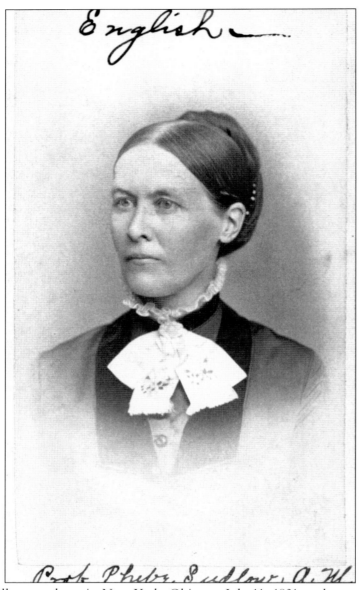

Phebe W. Sudlow was born in New York, Ohio, on July 11, 1831, and started teaching in Davenport in 1858 at School No. 5. She became principal of School No. 2 in 1860 at an annual salary of $400 and was appointed superintendent of the Davenport Public Schools in 1874. She was the first female principal and first female superintendent of schools in the entire United States. She also helped establish the first library in Davenport. In 1876, she became the first woman to be elected president of the Iowa State Teachers Association, and in 1878, she became the first female professor at the State University of Iowa when she took the position of professor of English language and literature and chairman of the English department. The photograph above was taken at that time. On June 14, 1921, when nearing her 90th birthday, the Davenport Board of Education voted to change the name of East Intermediate School to Phebe W. Sudlow Intermediate School. Interestingly enough, the bronze marker in the school commemorating the historic event has her name misspelled.

Anna M. Struve was a freshman at the Davenport High School when this picture was taken in 1887. She graduated in 1890 and started teaching at Walnut Hill School in Rockingham Township (now West Davenport) in 1893. By 1900, she was teaching at School No. 7, later called Van Buren. She eventually taught at West Intermediate School before retiring in 1933 after 40 years of service to local schools.

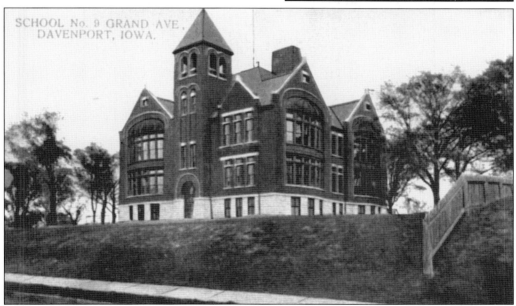

Built in 1892, School No. 9, later named Tyler School, was perhaps best known as the grammar school of Bix Beiderbecke. Beiderbecke has often been referred to as the greatest cornet player of all time, and this view of Tyler School is nearly the identical view he saw from his front porch. The school was razed and is now the site of Tyler Park, located in the 1900 block of Grand Avenue.

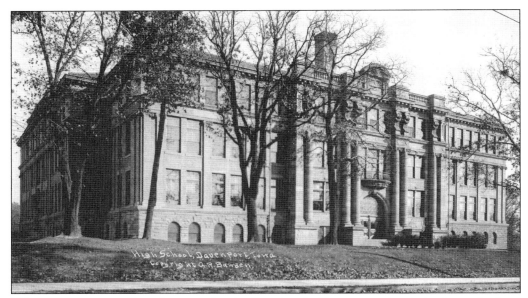

When women were allowed to vote for the first time in Davenport, they helped pass the issue of purchasing the Griswold College campus. The land was then used as the site for a new high school, which opened on January 21, 1907, and offered typing and stenography for the very first time to Davenport students. The total cost for furnishings, equipment, land, and construction was $400,000.

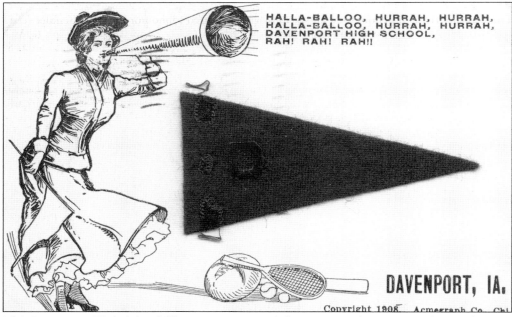

This Davenport High School felt pennant postcard shows a typical supporter of 1908 cheering on her team with the "halla-balloo." This is believed to be the first published school cheer in Davenport. The "cheer masters" were usually the most outgoing and outspoken males of the class in those days. Davenport High School did not have its first female "cheer leaders" until 1938. The melon–looking ball is what they used for a football in those days.

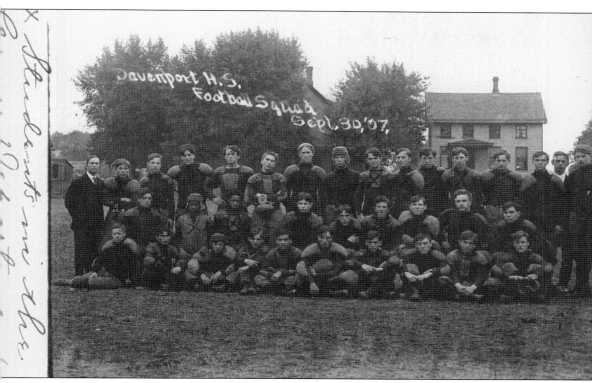

The Davenport High School football squad of 1907 featured sophomore Charles Schuler (class of 1910). He attended Cornell University and played on the Davenport Athletic Club (DAC) football team in its initial year of 1916. The DAC was the first of several professional football teams in the area. In those days, leather helmets, nose guards, and other protective equipment were strictly optional. Davenport High School did not play Rock Island High in 1907 because of a horrible incident that had occurred the previous year. Following the annual game with Rock Island in the fall of 1906, a young man, while attempting to seize a banner from a moving vehicle, was run down and killed. The accident was deplorable to say the least, and the seriousness of the affair was considered sufficient to sever all athletic relations between the two schools for many years.

Janitor J. F. Grant poses in front of the recently built School No. 14. In 1908, when numbered schools were renamed after their respective United States president, it logically would have been called Pierce School after the 14th president. However, it was named Buchanan after the 15th president because there were two presidents named Adams, with John Quincy Adams (the sixth president) being skipped. Buchanan School was located at West Sixth and Oak Streets.

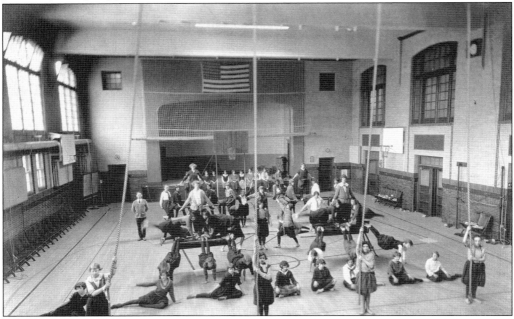

In this *c.* 1919 photograph, the girls' gym class posed with various apparatus used for physical training at the East Intermediate School gymnasium, now known as Sudlow Intermediate. When J. B. Young Junior High was built, the high school basketball games were played there until a new modern gymnasium was added to the high school. That gymnasium, known today as the George Edward Marshall Gym, was dedicated on February 23, 1930.

Six

THE CORNER STORE

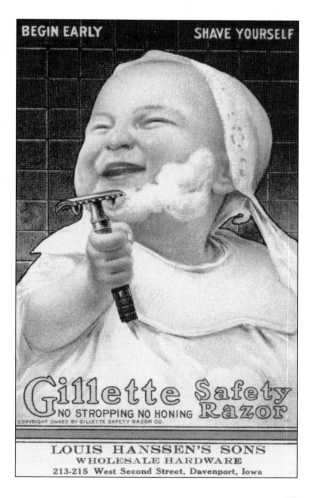

BEGIN EARLY SHAVE YOURSELF

Gillette Safety Razor
NO STROPPING NO HONING

COPYRIGHT OWNED BY GILLETTE SAFETY RAZOR CO.

LOUIS HANSSEN'S SONS
WHOLESALE HARDWARE
213-215 West Second Street, Davenport, Iowa

Louis Hanssen's Sons Wholesale Hardware was quick to advertise the new Gillette Safety Razor invented in 1903. It advertised no stropping or honing and indicated that even a baby could do it. Hanssen had been a resident in Davenport since 1849, opening a general hardware, crockery, cutlery, agricultural implement, and seed store in 1851. He lived upstairs of the business with his family for many years, until purchasing a home on the bluff overlooking the city. His hardware store was for many years the largest in town, and the business stayed in the family for almost 135 years.

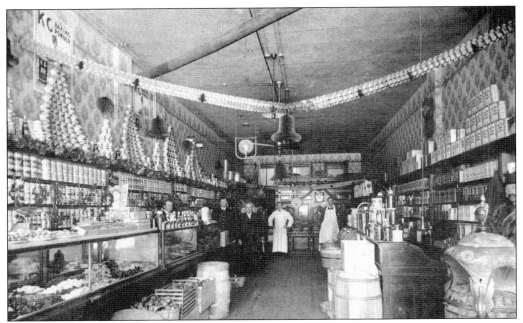

This is an interior view of Peter Peters' Grocery (1622 Washington Street) around 1889. Note the crates of fresh fruit and vegetables, boxes of Corn Flakes on the upper right shelf, and the potbellied stove. Back when the icebox was the only means of food preservation in the home, a daily trip to the corner grocer was nearly a necessity. The building still stands today as a four-plex apartment.

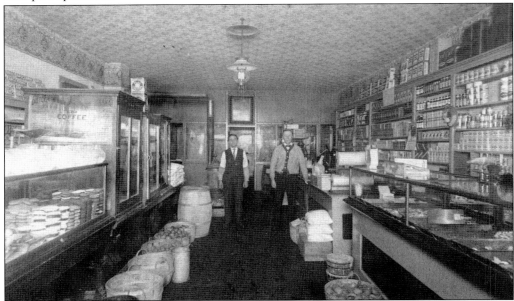

Here is the modernized Peter Peters' Grocery around 1900. Beef, pork, turkey, and veal were all priced at 10¢ per pound, while hens and spring chickens were only 7¢ per pound. Pete and wife Christina lived upstairs. He became vice president of the Northwest Davenport Savings Bank, forerunner of Northwest Bank and Trust Company.

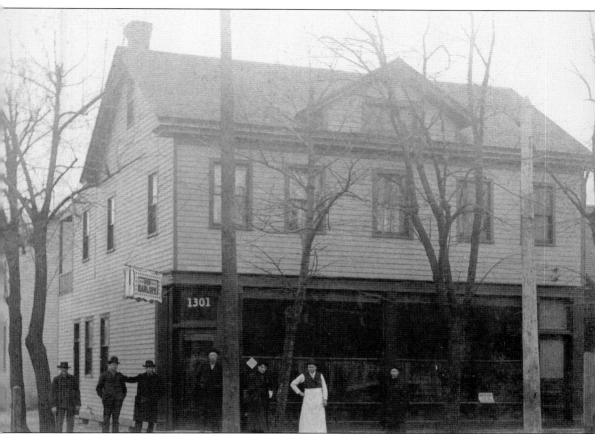

The Benjamin Harloff Tavern was located at 1301 West Third Street when this photograph was taken about 1910. Ben and his wife, Lena, lived upstairs. Davenport had over 150 saloons at that time for a population of 40,000. Before 1920, the tavern was purchased by Isadore Isenberg, who turned it into a grocery store, which served the community on Third and Marquette Streets for 25 years. The corner store remained through several ownership changes as Minkin's Grocery, Kinney's Market, and Fryxell's Market. In the early 1950s, subsequent owners tried their luck as a diner. The popular corner was successively known as the Pink Pig Restaurant, Butler's Café, Al's Café, and Pete's Midwest Café and Restaurant. In 1965, after careful consideration of business and clientele, Pete's Midwest Tavern and Beer Store was opened, and owner Pete Mathews completed the circle, returning the corner to a neighborhood tavern like it had been 50 years previous.

Above is a photograph of the Herman J. Arp Grocery store at 2002 West Fourth Street in 1907. By 1935, it became the location of the William G. Wundram Grocery, where they offered staple and fancy groceries and quality meats. William and Edna's son William (Bill) Wundram Jr. helped in the store and in 1943 graduated from Davenport High School, where he was president of the senior class and a member of the newspaper and annual staff. Shortly after graduation, he began work with the *Davenport Democrat and Leader* newspaper and is still going strong after 60-plus years of service. Today master columnist and associate editor Bill Wundram is an institution, sharing his personal musings, anecdotes, and insights into life to second- and third-generation readers of the *Quad City Times*.

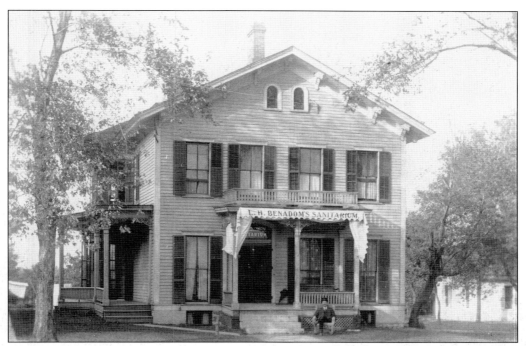

L. H. Benadom's Sanitarium, 637 East Fifteenth Street, offered compassionate care in a salubrious setting in 1908. W. A. Benadom also owned a sanitarium at 1403 Leonard Street (now West Thirteenth Street). Sanitariums were a kind of a private hospital or convalescent home for recuperation and treatment of chronic diseases and conditions. Today they are commonly referred to as nursing homes.

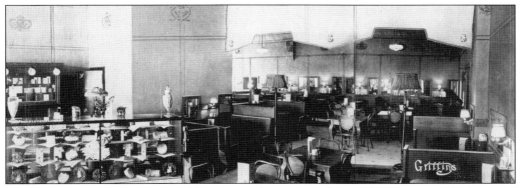

Griffins was a confectionery and lunch spot located on the northeast corner of Third and Harrison Streets. It had a nice selection of boxed candies for that special girl, and this store was a popular local meeting spot for the high school kids of the 1920s to chat, flirt, and gossip over a root beer float.

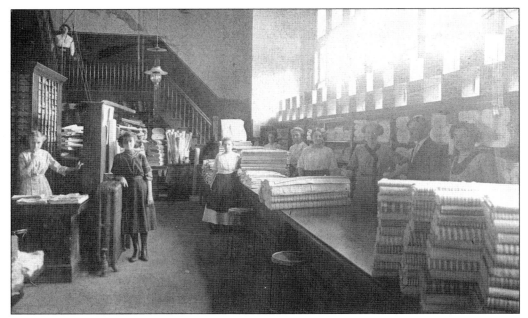

Before the 1920s, most clothing was made by hand. Sewing machines in the home were as common as a front porch and parlor. The millinery store offered material and accessories for the woman who not only made her family's clothes and linen, but also mended them regularly to save pennies in lean times.

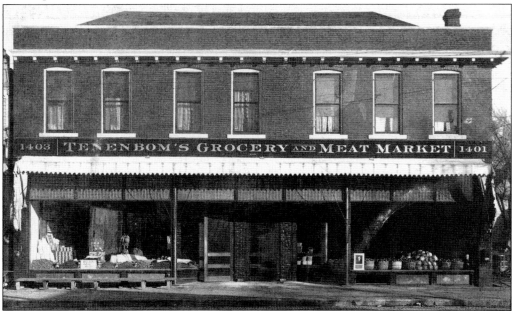

Tenenbom's Grocery and Meat Market was located uptown at 1401 Harrison Street. Roy and Rose Tenenbom lived upstairs with their family. To keep up with competition of the big downtown stores, they briefly started carrying a general line of goods and advertised as a genuine department store by 1920. Tenenbom's Grocery and Meat Market continued in the grocery line into the early 1950s until the store was sold, and the second floor was converted to apartments.

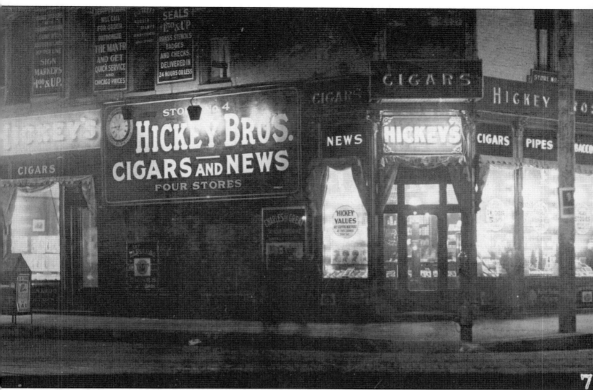

Hickey Brothers Cigars and News Store No. 4 was located at 302 Brady Street. They had three stores downtown at that time. The Hickey Brothers stores were not only a familiar sight in the Tri-Cities, but grew to 130 stores (some with full lunch counters) in 68 cities in 19 states, as well as Havana, Cuba. It became one of the largest cigar and candy retailers and wholesalers in the entire United States. They were found in railroad terminals and better hotel lobbies around the nation, including the Waldorf-Astoria in New York City. However, failing to adjust its infrastructure and business plan to changing times, it collapsed of its own weight, closing its doors forever in 1957.

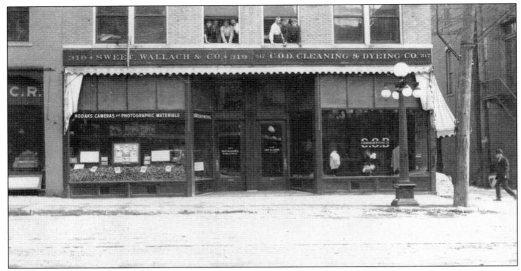

Everyone is enjoying posing for the camera above the Sweet, Wallach and Company photograph supplies store at 319 Brady Street, and C.O.D. Cleaning and Dyeing Company, 317 Brady Street. Levy and Louis Lasher of 1936 Grand Avenue were proprietors of the successful cleaners. Dry cleaners did a brisk business when such materials as wool, tweed, and gabardine were common everyday wear by everyone from store clerks to bank presidents.

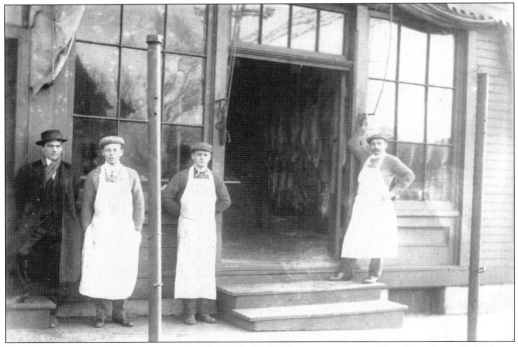

Butchers pose outside a meat market in 1911. Inside hung carcasses of beef, pork, and chicken, ready to be cut and wrapped to customer needs. Sawdust on the floor soaked up drippings, and sanitation was in the hands of the storekeeper. Only fresh meat was available, there were no walk-in coolers here.

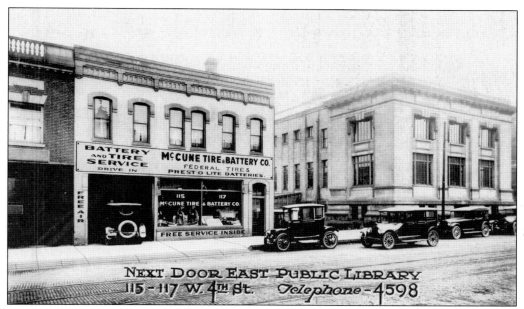

Edward McCune's Tire and Battery Company offered not only free air, but also free service in 1920. At that time, Davenport still had several livery businesses downtown where horses could be boarded, but they were fast nearing the end of a bygone era. More than 20 years had passed since Baron Otto Von Schaezler showed off the first locomobile in town on May 1, 1900. What a marvelous machine that was—a steam-powered, Stanhope two-seater model.

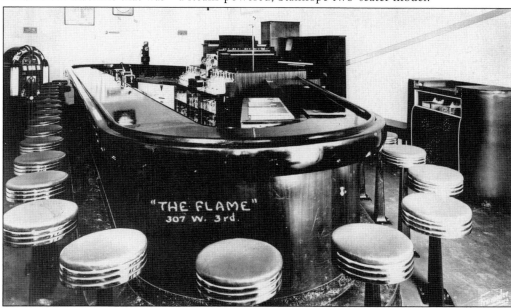

Jack Lingner opened his most unique bar, the Flame, at 307 West Third Street on August 21, 1945. Music could be played for a nickel in the Wurlitzer Model 950, when the stage was not featuring the best of local live entertainment. With the end of World War II, Americans were enthusiastic about enjoying themselves. Rum and Coke and Seven and Seven were the most popular adult social drinks.

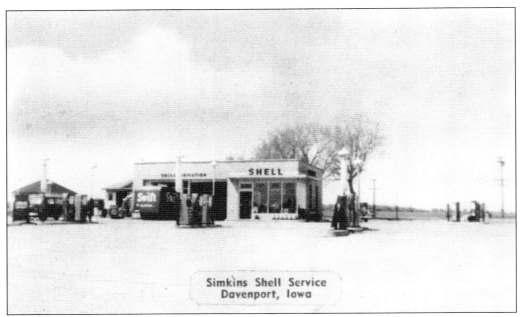

Simkins Shell Service
Davenport, Iowa

The Kimberly Road Outerbelt Bypass (U.S. Highway 6) was completed in 1936. When Simkins Shell Service opened at the junctions of U.S. Highways 6 and 150 (Kimberly Road and Harrison Street), it boasted of 23,500 square feet of concrete driveways with six pump islands for immediate service. Experienced attendants were on duty around the clock, offering a complete line of Shell products, including Dieseline-Premium gasoline and Dieseline-Rotella oils.

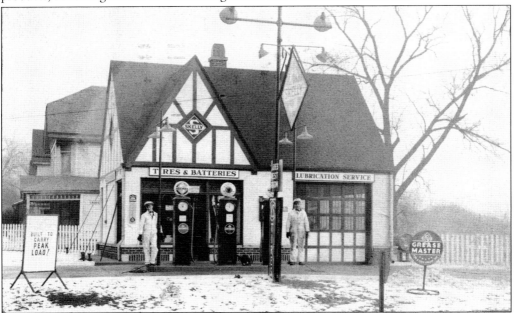

This is the Skelly Oil Company gasoline and service station, which sat on the southeast corner of Fourteenth Street and Pershing Avenue in 1935. Like the grocery store, most neighborhoods had a corner gas station in the days of true full service where the attendant filled the tank and checked the oil and tires.

Seven

BUSINESS AND INDUSTRY

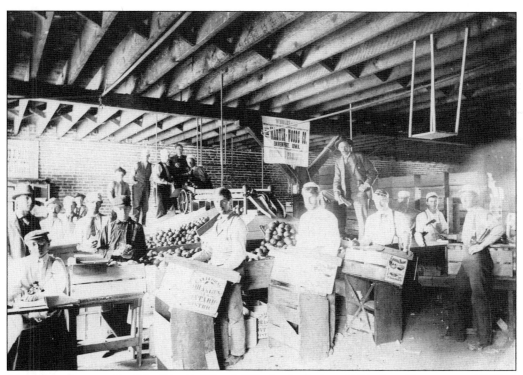

Above is a photograph of the Martin Woods Wholesale Fruits and Produce Company at 117 East Second Street. Charles D. Martin and Oscar C. Woods established the firm in 1888. They purchased fresh produce from the area and fruit like oranges from far off California and packaged them under their own Arsenal Brand for local distribution. Martin had been a resident of Davenport since 1848 and an astute businessman. He previously formed a partnership as Kelly and Martin Wholesale Liquor Merchants in 1880 with J. F. Kelly, who had also been a longtime resident in Davenport since 1846.

The Postal Telegraph Cable Company Office was located at 209 Brady Street in 1905. Employees included 15-year-old James Hall (front, right) and 14-year-old Robert Laughlan (front, left). In January 1865, the school of Pratt, Worthington, and Warner of Davenport introduced and successfully taught the subject of telegraphy, one of the first schools in the country to do so.

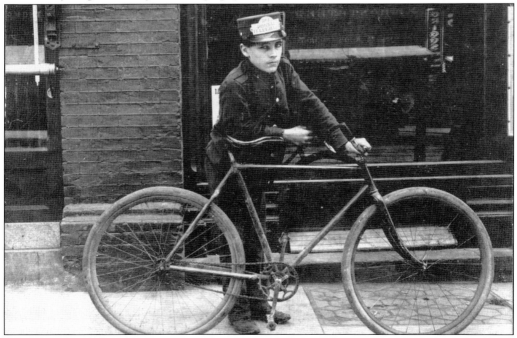

Delivery boy Laughlan poses with his bicycle. In the window reflection behind him can be seen the sign for Griggs Music House, located across the street at 121 East Second Street. In 1861, the telegraph extended west only as far as Davenport. Telegraphic news of the start of the Civil War that was sent to Davenport was then rushed by horseback to the governor in Iowa City.

HOTEL DEMPSEY
DAVENPORT, IOWA

When George S. Dempsey built the Hotel Dempsey in 1913 at 410 Main Street, he built the most modern facility, eclipsing the Kimball House and St. James Hotel in conveniences and comfort. This mid-1930s vintage postcard shows that the establishment had become more of a workingman's hotel, where a guest could go to the counter for an apple, Hershey bar of candy, Coca-Cola, smokes, or beer on ice.

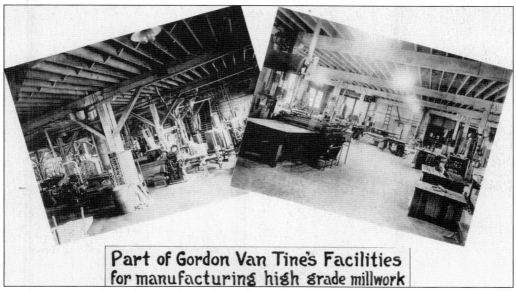

Part of Gordon Van Tine's Facilities for manufacturing high grade millwork

Gordon Van Tine's was known throughout the country for its ready-cut houses, or "houses by mail." Besides manufacturing under its own name, it also marketed homes through Montgomery Ward and Sears, Roebuck and Company. It issued its first house plan book in 1912, began its ready-cut line in 1916, and continued in business until 1945. It is estimated that the company sold close to 54,000 homes.

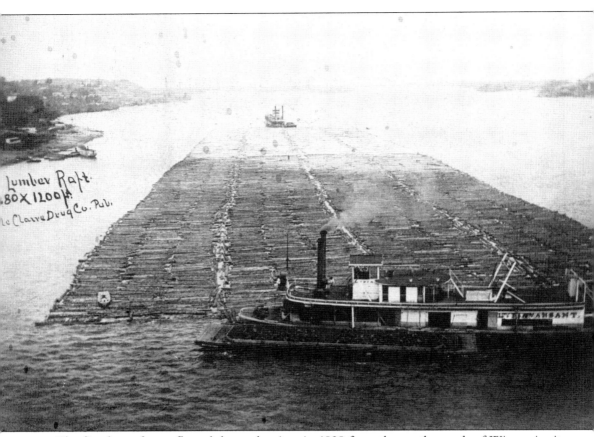

Lumber Raft.
80 X 1200 ft.
Le Clarre Drug Co. Pub.

The first log raft was floated down the river in 1838 from the north woods of Wisconsin, its course being guided by huge oars called sweeps. Later towboats were used to push and guide the great rafts, the last occurring in 1915. A steam-powered sawmill opened in 1849, the first in Davenport, and marked the beginning of the lumbering business, the most important industry in the area throughout the 1850s. In one of the most destructive fires in Davenport history, the Christian Mueller Sawmill and Lumberyard was completely destroyed on December 15, 1885. It was, however, able to rebuild and get back in business. Because of the dramatic drop of lumber from upriver, however, it ceased its milling operations in 1900 and went solely into wholesale and retail sales, including a brief stint in the coal delivery business in the 1920s. It was located on the southwest corner of Second and Scott Streets from the mid–1880s until its closing in the 1980s.

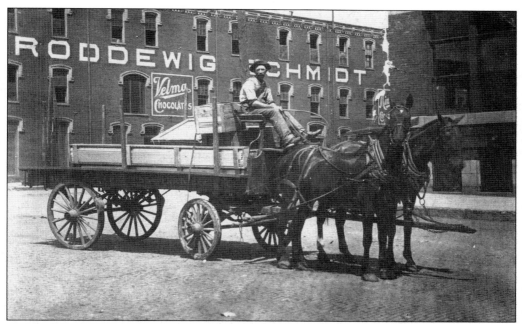

Originally a cracker company, Roddewig Schmidt later became a candy manufacturer featuring its Velma Chocolates brand. Velma was a dark chocolate of Austrian origin and, at that time, was the most popular among German-speaking areas. By the end of the World War II, the popular sales to Germans had swung to sweeter milk chocolate. The building shown here around 1899 was on the northwest corner of Fourth and Iowa Streets.

Attractive and often humorous advertising cards were common attention getters before 1900 and were also prized additions to family scrapbooks at a time when any colorful clipping became a keepsake. Originally founded in 1872 as the Joseph M. Christy Cracker Company, it later became the Reupke-Schmidt Cracker Company in 1878, Roddewig Schmidt Cracker Company in 1887, and was finally absorbed by the American Biscuit and Manufacturing Company in 1898.

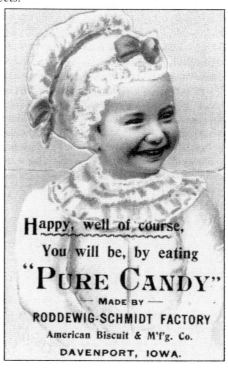

Happy, well of course,
You will be, by eating
"PURE CANDY"
— MADE BY —
RODDEWIG-SCHMIDT FACTORY
American Biscuit & M'f'g. Co.
DAVENPORT, IOWA.

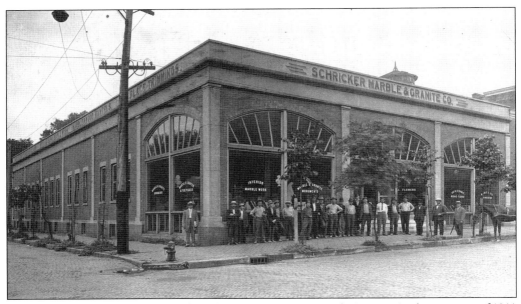

The employees of Schricker Marble and Granite Company took time out in the summer of 1911 to pose for the camera. Men wore hats nearly as often as they wore trousers in those days. The company was located at 402 Scott Street across from the courthouse. The company specialized in mausoleums, sarcophagi, vaults, graveside marble and granite monuments, and interior work, including mantels, grates, fireplaces, wainscoting, and mosaic floors.

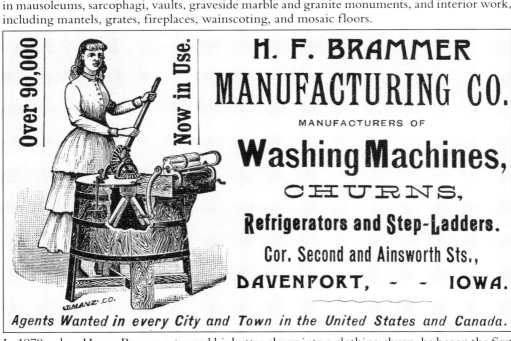

In 1878, when Henry Brammer turned his butter churn into a clothing churn, he began the first wash machine manufactory in town. By 1890, Davenport was considered the washing machine capital of the world, claiming 60 percent of all American production, and included the companies of H. F. Brammer Manufacturing Company, Home Manufacturing Company, Voss Brothers, and White Lilly Manufacturing Company.

Larger local merchants would sometimes manufacture their own money or script, which was a promissory note redeemable for goods at any time. This would ensure that the patron would spend his note at the owner's establishment. Derisively known as "shinplasters," they were often considered worthless—better to line boots with them than take them as currency. This practice was repeated extensively during the Great Depression in the 1930s when money was in short supply. The script above was issued in 1862 during the Civil War and worth 5¢ at the hardware store of John C. Washburn. Washburn personally numbered each note and signed the reverse in red ink. His store was on the south side of Second Street, east of Brady Street. His home was not far away on the east side of Brady Street, north of Fifth Street.

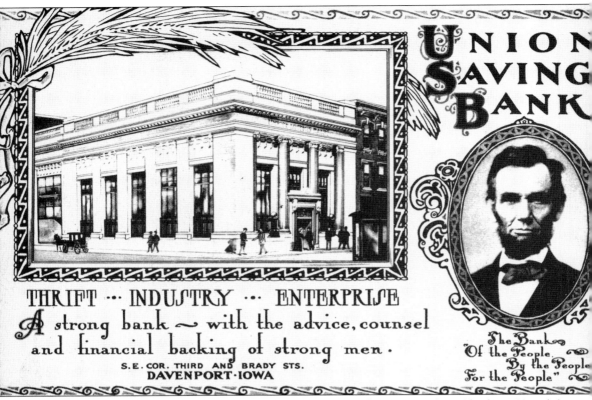

THRIFT ··· INDUSTRY ··· ENTERPRISE

A strong bank ~ with the advice, counsel
and financial backing of strong men.

S.E. COR. THIRD AND BRADY STS.
DAVENPORT·IOWA

UNION SAVING BANK

"The Bank
Of the People.
By the People
For the People"

This postcard from the Union Savings Bank portrayed former president Abraham Lincoln's portrait. Lincoln had strong ties directly to the area of Davenport. As a young lawyer, he had successfully helped defend the rights of passage of the railway over the Mississippi River Bridge, and his Republican nomination over Edward Bates for the presidency was greatly credited to the many Davenport Germans of the Turner Society. Even the slavery issue was linked to Davenport when Dr. John Emerson transported his slave (Dred Scott) to the free land in Iowa, challenging the basic foundations of freedom, which would prove to be influential in fanning the flames of the looming Civil War. When the $1 million Union Davenport Trust and Savings Bank was built in 1923, it offered prospective tenants the latest innovations, including circulating ice water, compressed air, gas, and high-tension electric current. However, in 1932, the bank was forced to close due to the panic that began in the fall of the previous year.

The White Yard, located at 901 East River Drive, dealt in lumber, coal, and implements around 1913. The lumber industry had been so important to the area in the 1850s that there were six sawmills and 10 lumberyards in Davenport alone in 1856. On July 25, 1901, Davenport was decimated by the most destructive conflagration in its history. The alarm came in at 5:00 p.m. on Thursday afternoon, and 15 minutes into the battle to check the fire, the effort was rendered useless. The flames started in the wood yard of the Rock Island Fuel Company and quickly spread to the Weyerhaeuser and Denkmann sawmill before moving north. From the river to Sixth Street and from Tremont to Oneida Avenues, everything was a complete loss. Hundreds were left homeless, and the damage was in excess of $600,000. Around 2,000 feet of street railway tracks were destroyed by the fire, which also warped Chicago, Milwaukee and St. Paul Railroad rails and destroyed the trestle bridge. Firemen desperately battled the fire for three days with little success.

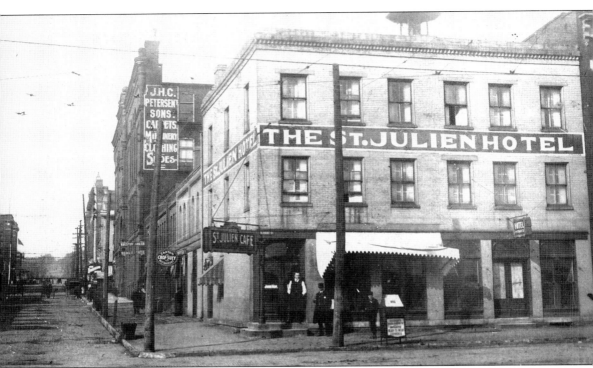

The St. Julien Hotel (formerly the Metropolitan Hotel) would have been one of the first boardinghouses in view when coming in on a steamer. Front Street was a natural area for such establishments and in 1888 included the Washington House (116 West Front Street), Davenport House (118), Perry House (120), Schauder's Hotel (126), St. James (northwest corner of Main and Front Streets), and the Lindell Hotel (214–218). Pictured above, the proprietor of the St. Julien Hotel poses with the constable in front of the cafe. Behind it sits the Canton Chop Suey Restaurant, Koester Land Company, and the J. H. C. Petersen's Sons Store, whose sales made it the largest store of its kind in the state. In 1916, after the death of his father and brothers, William Petersen sold the department store to Rowland H. Harned and Charles J. Von Maur, the owners of the six-floor Harned and Von Maur Department Store, formally known as the "Boston Store," located one block west. Both stores remained opened in direct competition with each other until 1927 when the Harned and Von Maur Department Store was closed.

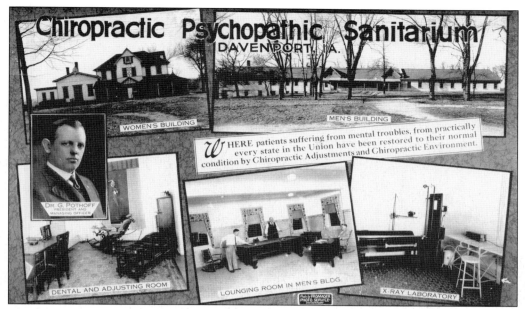

Chiropractic Psychopathic Sanitarium
DAVENPORT, IA.

WOMEN'S BUILDING

MEN'S BUILDING

*W*HERE patients suffering from mental troubles, from practically every state in the Union have been restored to their normal condition by Chiropractic Adjustments and Chiropractic Environment.

DR. G. POTHOFF
PRESIDENT AND MANAGING OFFICER

DENTAL AND ADJUSTING ROOM

LOUNGING ROOM IN MEN'S BLDG.

X-RAY LABORATORY

Thanks to Dr. B. J. Palmer, Davenport will forever be known as the chiropractic fountainhead. The success of his business attracted many other chiropractic schools and related businesses. Among the schools located here were Brown's Sanatorium, Davenport College of Chiropractic, Sharp and Carlson, and the Universal Chiropractic College. In the early 1920s, Dr. George Pothoff opened his Chiropractic Psychopathic Sanitarium in Forest Park (previously known as Scheutzen Park) on Hickory Road north of Telegraph Road.

Miller's Hotel was located at 712 West Second Street in what is now the German American Heritage Museum. By 1920, there were 29 hotels in Davenport.

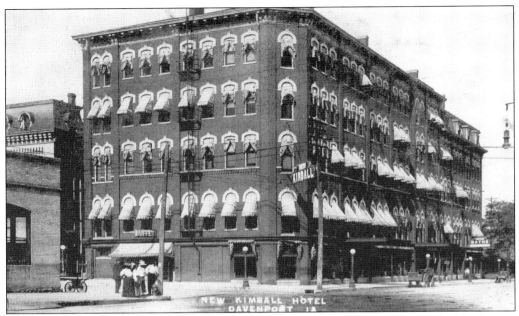

The Kimball Hotel sat on the northeast corner of Fourth and Perry Streets. A Turkish bath, nice buffet, bar, and sample rooms were also part of the hotel, and the opera house was in connection next door. Artesian water was used exclusively on its tables. In 1917, the building was converted to the Perry Apartments, where future president Ronald Reagan lived while working as an announcer for WOC radio.

The Davenport Wagon Company occupied the northwest corner of Third and Farnam Streets where the *Quad City Times* building now sits. It was purchased by French and Hecht Company in 1909 and became the railroad car truck/wheel operation. Davenport was the leading manufacturer in the United States of steel agricultural and tillage implement wheels.

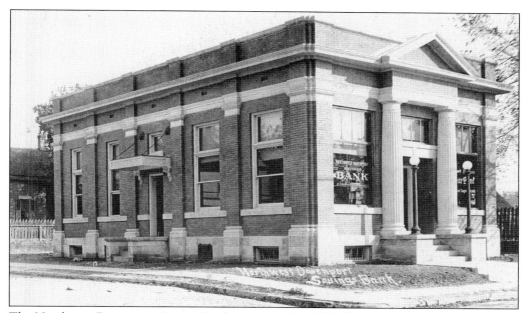

The Northwest Davenport Savings Bank was located at 1529 Washington Street around 1912. According to the window, it offered four percent interest on all deposits. In 1941, the bank reopened as Northwest Bank and Trust. The bank employed only three people at the time of this inauspicious beginning. But by 1953, the company had completely outgrown the building, and a brand-new modern bank was built at 1454 West Locust Street.

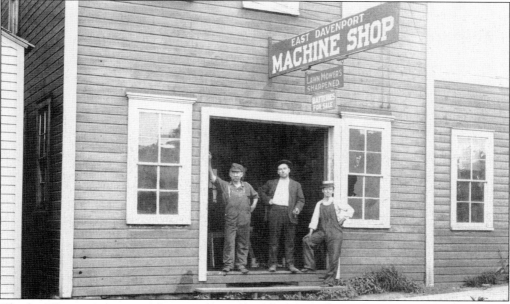

Charles Thomann poses with manager William Waters around 1913 at his East Davenport Machine Shop. Located at 408 Mound Street, they were mechanical engineers and manufacturers of special machinery and parts and did machine blacksmithing. By 1920, it was decided that the addresses given in the east village did not align with those in neighboring Davenport, and the shop's reassigned address became 1108 Mound Street without moving an inch.

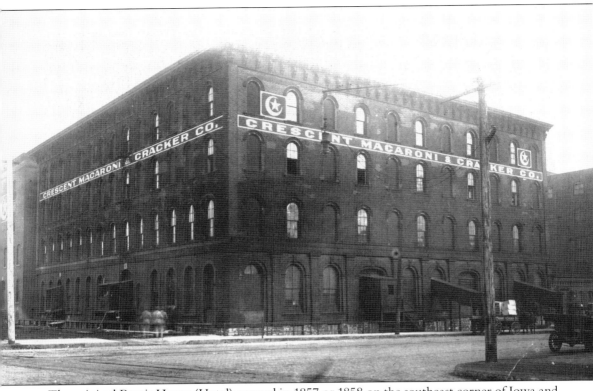

The original Burtis House (Hotel) opened in 1857 or 1858 on the southeast corner of Iowa and Fourth Streets (J. J. Burtis, proprietor). Gov. Samuel J. Kirkwood and Adj. Gen. Nathaniel B. Baker and his staff took advantage of its furnishings when using it as Iowa's military headquarters during the Civil War. In 1894, the Loose brothers of Chicago bought the building, converting it to the Crescent Macaroni Company. It was one of the first pasta manufacturers in the entire country and the only one in Iowa. In 1904, it became the Crescent Macaroni and Cracker Company when it introduced crackers and cookies to its product line. However, in January 1915, a tragic fire, which lasted four days, destroyed the plant, leaving 300 people without a job. A year later, the rebuilt factory was opened at the same location and included a large water tower on the roof in case of fire. Another fire, also in 1915, had devastated the Davenport Vinegar and Pickling Works. By 1924, Crescent Macaroni and Cracker Company was the largest macaroni manufacturer in the entire country.

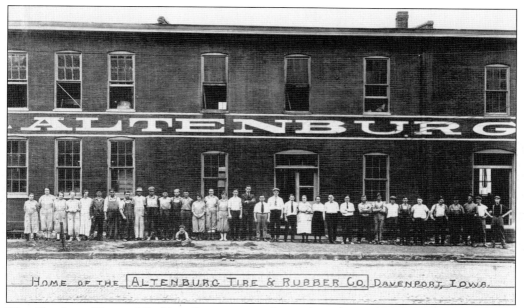

The Altenburg Tire and Rubber Company was located at 2505 Rockingham Road and was just one of the dozens of fine manufacturing businesses in a town with ample opportunities for making a good living. In 1910, Davenport was listed as America's second-richest city based on the United States census of per capita wealth.

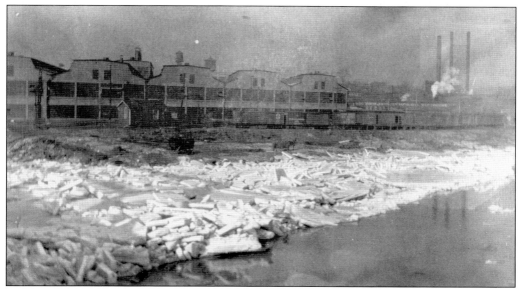

The Red Jacket Pump Factory was located along the river at 602 East Third Street. The absence of the seawall dates this picture before 1912. Minutes after receiving the telegraph news of the armistice of World War II, at 2:00 a.m. on November 11, 1918, every factory in the area had their whistles blaring. By 3:00 a.m., the streets were filled with thousands of jubilant citizens forming impromptu parades in utter pandemonium.

The Tri-City Mill and Feed Company was the home of Dr. Dick's Malted Stock Food. The mill was not located out in the country but alongside the railroad tracks at 1726 West Third Street, the current site of Dixon Auto Sales. It became the Red Mill, supplying coal and wood by 1919.

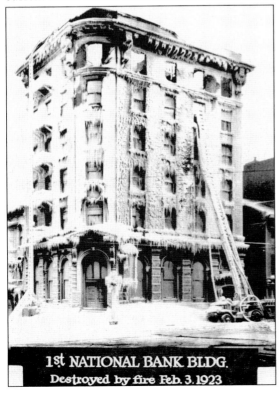

1st NATIONAL BANK BLDG.
Destroyed by fire Feb. 3. 1923

The First National Bank was located on the southwest corner of Second and Main Streets. Businesses above the bank included the Bradstreet Company, Dr. George M. Middleton (physician and surgeon), the George W. Cable Lumber Company Office, and William Coffee, M.D. (oculist and aurist). The bank succumbed to a terrible subzero winter fire, was rebuilt on the same site, and later merged with the Union Bank and Trust Company.

Eight

TRAVEL

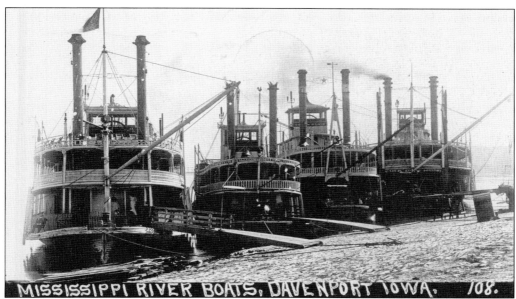

MISSISSIPPI RIVER BOATS, DAVENPORT IOWA. 108.

Four large steamers dock at the Davenport levee. The third boat from the left was the *Helen Blair*, built in 1896 and originally named the *Urania*. In the summer of 1901, it was sold to Capt. Walter Blair, who named the boat after his daughter Helen and used it mostly to run local trade out of Burlington, Iowa. On September 5, 1901, a fire burned the pilothouse and Texas deck below it, and the boat was rebuilt that winter in the Kahlke Boat Yard at Rock Island. In 1913, it docked at Galena, Illinois, and was the first boat in years to do so; in fact, it proved to be the last. In 1916, it made a round trip from Davenport to New Orleans, and in 1920, it was finally dismantled forever in Memphis.

Here is the original invitation and ticket to the Union Railroad Party, which was given at the New Mississippi and Missouri Railroad depot in Davenport on Tuesday evening, October 7, 1856. Honorary managers included Henry Farnam, Ebenezer Cook, Gen. George B. Sargent, Antoine LeClaire, and others. According to the city directory of 1856, the Mississippi and Missouri Railroad was first organized in 1853.

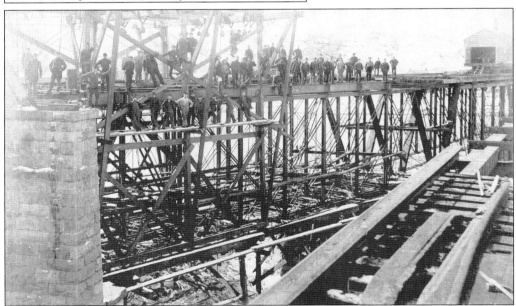

Pictured above is the second Government Bridge under construction in late 1895 or early 1896, originally from the collection of bridge worker Willie Kline. This bridge was made of steel and is in use to this day. Building bridges is a dangerous occupation, especially back in the 19th century. Note the snow on the scaffolding and bridge abutments.

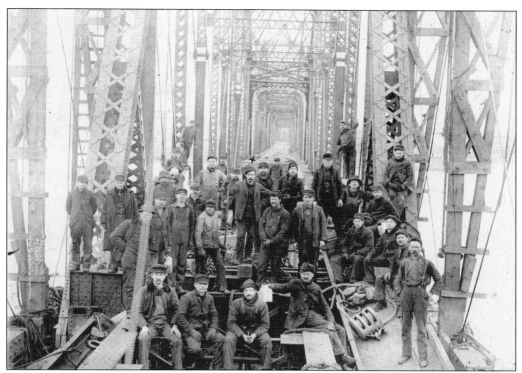

In this photograph, the end of the draw span is shown near the Rock Island side. Bridge worker Willie Kline is in the center, with an "X" over his head.

Abel Kimball, assistant to the president of the Chicago Rock Island and Pacific Railroad, signed this ticket of passage to Columbus Junction, Iowa, for W. C. Brown. The depot sat at 426 Rock Island Street (renamed Pershing Avenue) at the back door of the Kimball House Hotel, which had been named after Kimball in 1880.

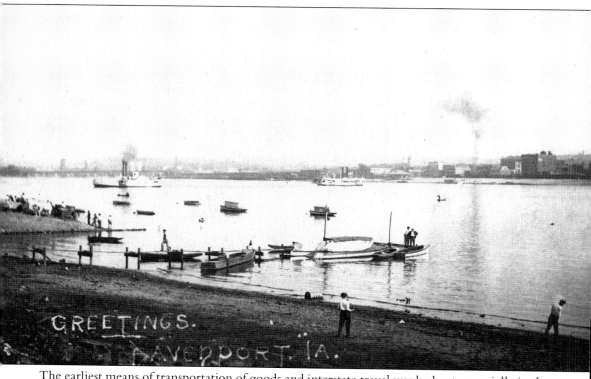

GREETINGS.
DAVENPORT. IA.

The earliest means of transportation of goods and interstate travel was by boat, especially in the days prior to the Civil War. But by the end of the 19th century, river commerce had stagnated, the Davenport levee served as the city dump, and the water's edge was filled with dilapidated shanty boats. Through the vision of William D. Petersen, however, the first Levee Commission in the entire United States was formed in 1911, and he soon spearheaded the construction of the seawall, riverfront park, and revitalization of the area's greatest asset. The improvements were named after the city's founding father at the dedication in 1918, and today Antoine LeClaire Park is a beautiful and historic venue for riverside summer strolls and outdoor concerts, including the Bix Beiderbecke Jazz Festival.

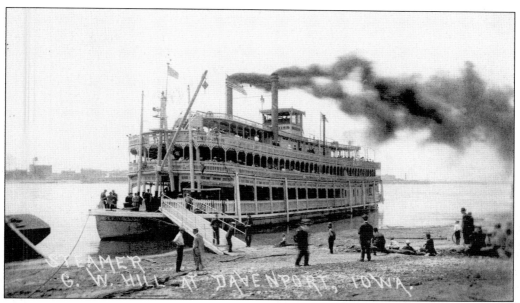

The stern-wheeler steamer *G. W. Hill* docks at the steamboat landing at the foot of Main Street. The boat was named after Granderson Winfree Hill, a pioneer steamboat captain and one of the founders and directors of the Eagle Packet Company of Warsaw, Illinois. It was launched in 1909 and was destroyed by fire in 1932.

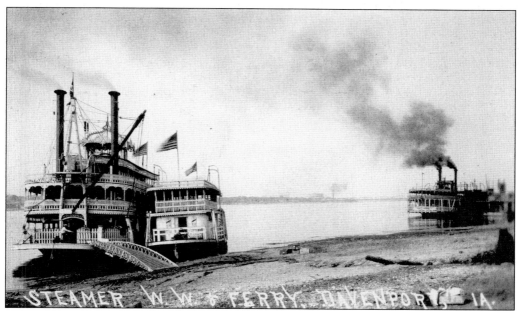

A typical levee scene in 1912 shows a packet steamer named *W. W.* and the *Davenport* ferry stern-wheeler at the far right. The little boat next to the *W. W.* may have been the *Rock Island*, a smaller ferry that ran in tandem with the *Davenport* ferry. The *Davenport* ferry, on the right, carries a banner on front advertising the coming Boat Regatta Fireworks.

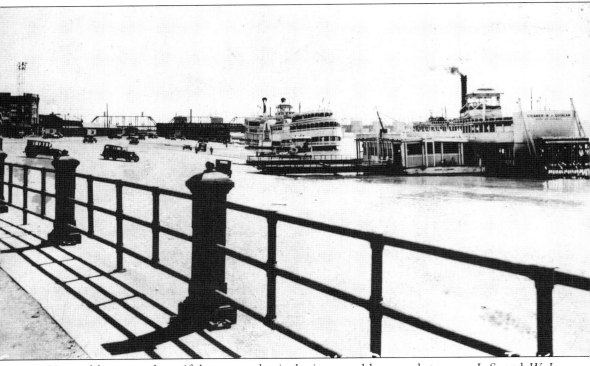

Pictured here on a beautiful summer day is the improved levee and steamers *J. S.* and *W. J. Quinlan*. The *W. J. Quinlan* served to ferry passengers of the Tri-Cities for over 40 years. The *J. S.*, which was owned and captained by John Streckfus, was an upper Mississippi River packet, running excursions from Davenport and Clinton. On June 18, 1910, while on excursion from LaCrosse, Wisconsin, to Lancing, Iowa, a passenger confined to the brig set the boat on fire, killing himself and a lady passenger at Bad Ax Island.

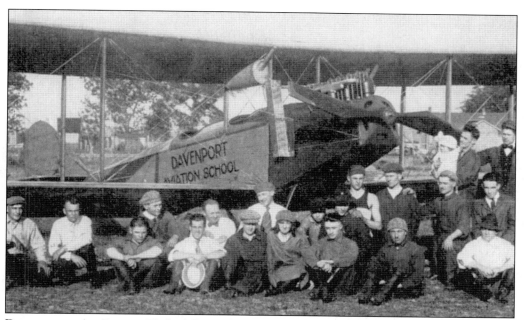

Davenport native Eugene Ely had flown the first successful airplane flight north of St. Louis at the Rock Island Exposition Grounds in 1910. By 1930, the Davenport Aviation School taught the art of flying and manufacturing of "aeroplanes," both land and water. It also operated a passenger-carrying service at Cram Field. The city directory located the airfield at Division Street and Duck Creek. Today it is the site of Northwest Park.

This rural setting of the Chicago, Milwaukee and St. Paul Railway Company tracks in northern Davenport no doubt looks much different today and is probably unrecognizable. In 1869, the Transcontinental Railway through Davenport was completed at Promontory Point with the driving of the golden spike, a vision first introduced in 1842 by local entrepreneur Ambrose C. Fulton.

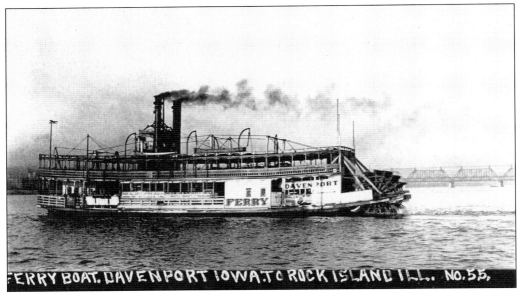

The *Davenport* ferry was built and launched from the Kahlke Boat Yard in Rock Island in 1904. The Rock Island-Davenport Ferry Company continued operation until 1924, when it was purchased by William J. Quinlan, who changed the name of the *Davenport* ferry to the *W. J. Quinlan*. In 1945, the boat was condemned by the U.S. Coast Guard and on April 8, 1967, was set afire and completely destroyed by vagrants.

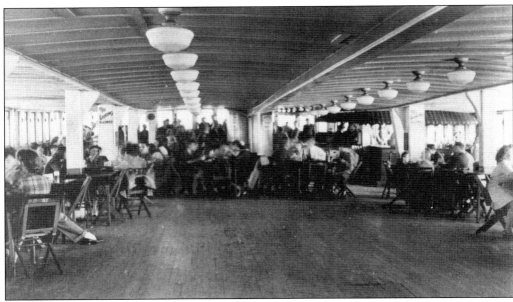

The *Davenport* ferry was not only a means of transportation, but also a place of entertainment. In those days, a person could ride all day on the upper deck for 10¢. Bands provided music, featuring local artists such as Bix Beiderbecke and future Hollywood star June Haver. In the 1930s, one could dance, drink, gamble, and play bingo. The boat's popularity as a floating nightclub peaked perhaps during World War II.

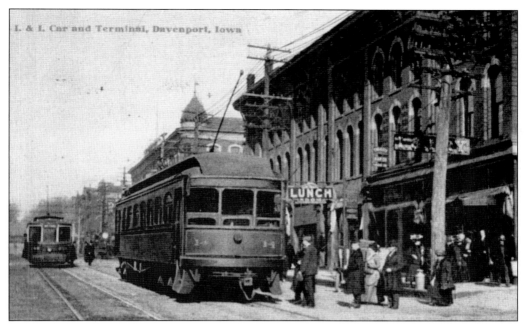

Beginning in 1904, the Iowa and Illinois Railway provided electric streetcar service called interurbans for scenic and reliable transportation between local towns. The Iowa and Illinois Railway passenger depot and newsstand was a busy place at 217 Brady Street and included the businesses of Joseph Delfino's Shoe Shine, J. L. Traxler Billiards, and Western Union Telegraph. Next door, the Merchant's Cafe was a popular and handy spot for lunch.

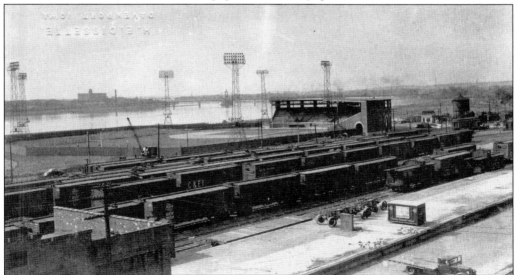

This postcard shows the important train yard activity shortly after the completion of the Municipal Stadium in 1931. The Centennial Bridge would not appear until 1940. Trains were a major means of transport of produce and manufactured goods in America, although, like business in general, they were hit hard in the 1930s due to the Great Depression. The Davenport Locomotive Works, which was in business from 1902 to 1956, was for many years the only train manufacturer west of Pittsburgh.

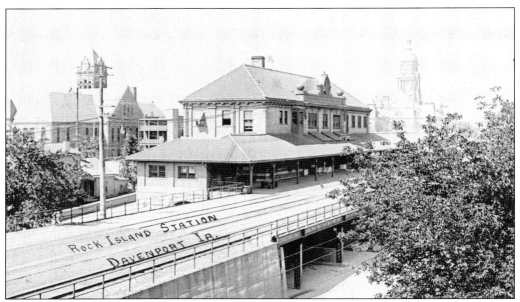

In 1901, the Chicago, Rock Island and Pacific Railroad constructed a new passenger terminal at Fifth and Main Streets, elevated its Fifth Street route through the city, and expanded the line from two to four tracks. The elevated tracks solved the constant interruption to normal traffic flow, which by 1907, grew to 69 daily passenger trains, making Davenport the fifth city of importance in the entire line.

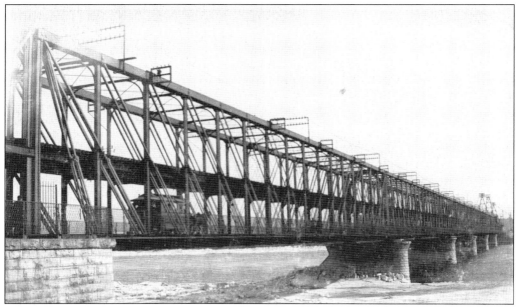

A horse-drawn trolley provides transportation on the Government Bridge about 1897. The Tri-Cities (Davenport, Rock Island, and Moline) were united by streetcar lines for the first time when cars began running across bridges on December 24, 1888. Ironically the very last streetcar to go out of use ran the Government Bridge line shown above, making its final passage on the morning of April 16, 1940.

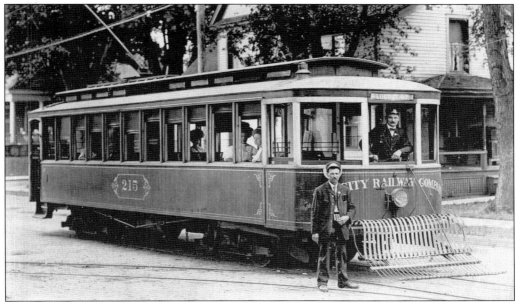

The author's great-grandfather Henry Faye Bowker was a conductor for Tri-City Railway and stands in front of his streetcar on East Locust Street in this image. The houses behind are still there at 1826 Farnam and 607 East Locust Streets.

By the late 1920s, automobiles had become more common and affordable to the average home, and travel was becoming less dependent on public transportation. Auburn and Jordan motorcars and farm tractors were sold by the H. W. Neuman Machine Company of 407 West Third Street. Next door was the Jacob M. Lenz Photography Studio (409–411) where hairdressing, draperies, and flowers were furnished.

Buses replaced electric streetcars on some routes for the first time in 1926, and by the mid-1930s, streetcars were nearly extinct. Automobile, bus, and taxi travel were becoming the most popular forms of public transportation. This view looking east on Third Street at Harrison Street shows Bond Drug on the northeast corner, with the U.S. Postal Station No. 4 located inside. This had previously been the location of Hickey Brothers Cigar Store No. 6, which previous to that was Berg Brothers Sporting Goods. Also on that side of the street were the Royal Cab Company (240), Furniture Mart (232–234), and Schneff Brothers Jewelers (224). Across the street were Emeis-Hansen "Owl Drug" Company (229), the State Theatre (215), and Davenport Bank and Trust.

Nine

ENTERTAINMENT

The Kahl Building, built by the Walsh Construction Company of Davenport, was completed in 1920 at a total cost of $1.5 million. Located on the northeast corner of Third and Ripley Streets, it featured the 2,500-seat-capacity Capitol Theatre. It was also the first theater in Davenport to be air-conditioned, getting forced air-cooling from an underground well. At that time, the city had 20 theater and motion picture houses. On January 29, 1959, Buddy Holly, Ritchie Valens, the Big Bopper, and others appeared there as part of the "Winter Dance Party," just days before the tragic plane crash that took their lives.

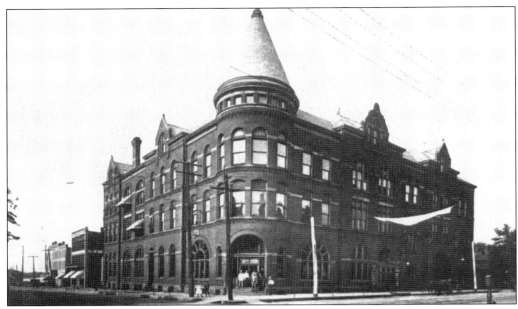

The Central Turner Hall was located on the southwest corner of Third and Scott Streets. Besides a gymnasium, the building held a saloon, a restaurant, and the German Theatre (the Grand Opera House). During the great influenza epidemic of 1918, over 7,500 people were stricken and approximately 2,000 died. The hospitals were so overrun that makeshift units were set up at the Central Turner Hall, and the entire city was effectively under quarantine.

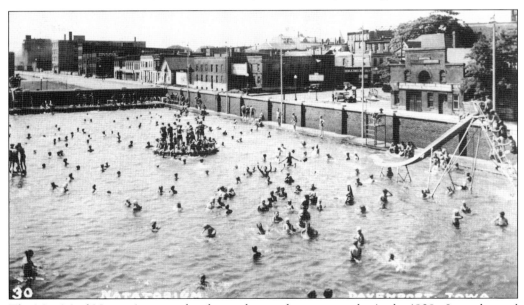

The Municipal Natatorium was the place to be on a hot summer day in the 1920s. It was located on West First Street between Main and Harrison Streets. Across the street, on the northwest corner of First and Harrison Streets, was the Witt Bottling Works, and on the same corner three blocks west (on Gaines), sat the H. D. Baker Bottling Works (two early soft drink manufacturers). The Municipal Natatorium ("Nat") was razed in 1981.

Don't Forget the Date
SEPT. 7, 8, 9, 10, 11, 1891.
Davenport Fair and Exposition,
DAVENPORT, IOWA.
Exhibits larger than ever. Amusements for "Old and Young." Bring the Babies.
EXHIBITION OF PRIZE BEAUTIES JOE L. HEBERT, SEC'Y.

Perhaps the event of the year, the Davenport Fair and Exposition was held at the fair grounds, known as Central Park. In 1892, the great horse Allerton from Independence, Iowa, was injured in a race against Lobasco in Davenport, was retired for the remainder of the season, and never raced again. Buffalo Bill Cody first orchestrated his Wild West Show at the circus grounds west of Central Park in 1884.

FOUNTAIN, CENTRAL PARK, DAVENPORT IOWA. 93.

The Main Street entrance to Central Park shows the original fountain. The land had previously been the Scott County Fair Grounds until purchased by the city for $13,500 in 1885. It was renamed Vander Veer Park in 1911. One of the attractions of the park and a valuable source of education was the birdhouse exhibit, which contained more than 400 rare and foreign birds. It was donated in 1913 by Frank Snell.

119

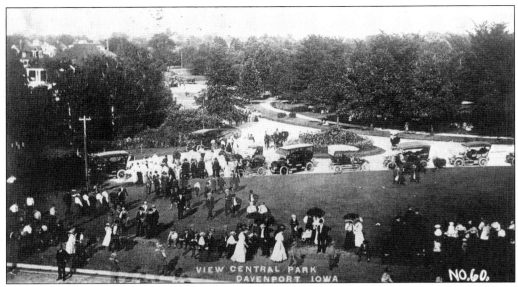

In 1915, large crowds attended concerts that were given every two weeks during the summer months on Sunday afternoons in Central Park and Fejervary Park, alternately. It was against the law to drive or ride in any vehicle in the park during such concerts, and it was also unlawful to play football, golf, cricket, baseball, or any other games of like character in any park at any time.

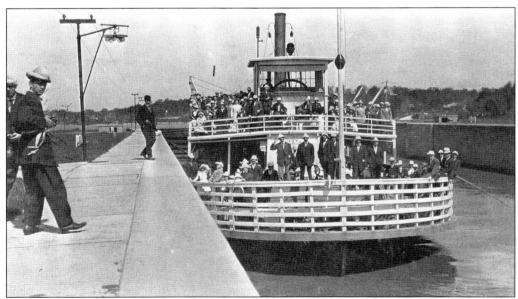

Taking a Mississippi River excursion was a common entertainment back in the days of the big steamboats. Here the Palmer School of Chiropractic class of 1910 pauses for a picture while going through the government locks. The writer of this postcard stated they were out on a picnic with their "whiskers and paper hats." A whisker was a pet name for a whiskey flask.

WOC television station was the first in Iowa and was originally broadcast on Channel 5. This postcard highlights the popular personalities of that first year of operation (1949–1950). Louis Thomas of 2326 Jersey Ridge Road owned the first television set in the Quad Cities. He paid $1,400 for it and purchased it many months before WOC went on the air.

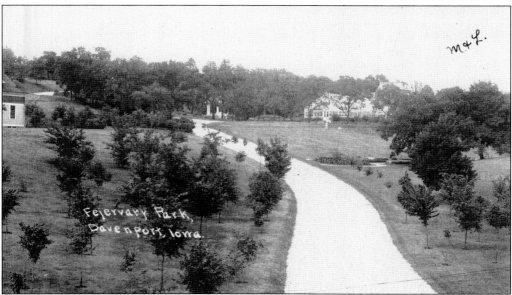

Fejervary Park once had a band shell, floral gardens, a conservatory, and an inn. Labor and maintenance costs were not quite so formidable in those days, and such amenities were kept in top condition for the enjoyment of visitors who were more respectful of city property. The floral gardens sat where the current swimming pool is. Only the storage barn on the far left remains today.

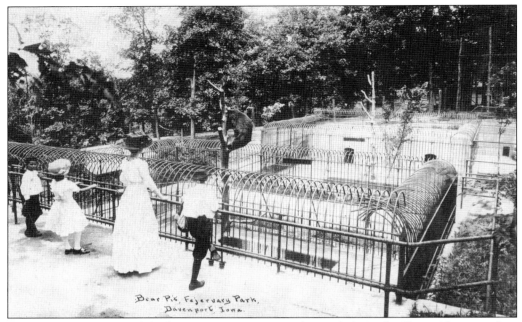

Fejervary Park contained the first zoo in Davenport and provided city dwellers with an up-close look at many animals, including bears, which were native to the area 50 years earlier. Even great flocks of parrots lit up the trees with magnificent rainbows of color in the southern counties. Unfortunately, they were easy marks and were quickly eliminated forever as native fauna.

Scheutzen Park, like most of the other parks in Davenport, was a destination designed to provide multiple forms of entertainment and all-day attractions similar to the amusement parks of today. Ironically the only structure left of this magnificent facility is the main entrance streetcar waiting station. Today it is listed as an historic city landmark.

On January 29, 1869, a contraption called the bicycle was first introduced to the people of Davenport in a stage show held at the Burtis Opera House (415 Perry Street). In 1921, an escaped patient from the Independence (Iowa) Hospital for the Insane set fire to five downtown buildings, destroying the roof and upper level of the opera house. The building still stands today as the Tri-City Electric Company.

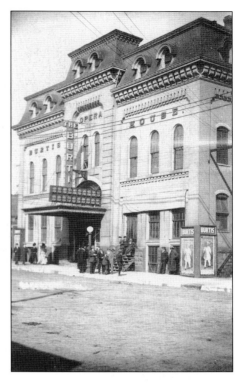

BLANCHE RING.

This postcard heralds the appearance of Blanche Ring in her new musical comedy *The Wall Street Girl* at the Burtis Opera House on January 10, 1912. The advertisement on back extolled the many beautiful showgirls distinctly featured in the show. Among the famous to appear at the Burtis Opera House over its lifetime were Mark Twain on January 31, 1885, and John Philip Sousa and his 100-piece band in 1895.

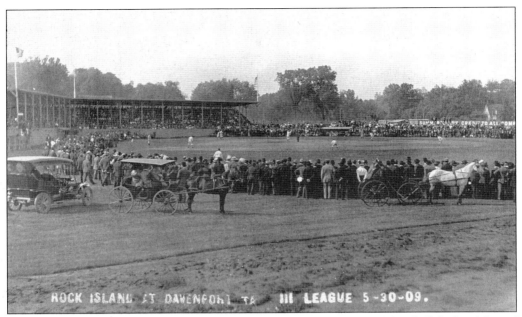

The Three-I League (Iowa, Illinois, and Indiana) provided professional baseball for local fans of America's favorite pastime. As no home run fence was set up in those days, long balls and foul balls were a shear delight, as fielders sometimes became cozy with spectators. The billboard along left field advertises Summerfield's Furniture Company (115 East Second Street). Games were played approximately where St. Mark's Church now sits at the west end of Third Street.

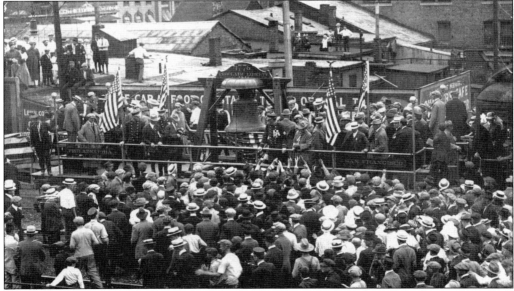

People were standing on rooftops to get a glimpse of the Liberty Bell arriving by train and on display at the Rock Island Station in 1915. It was traveling from Philadelphia to San Francisco for display at the Panama-Pacific Exposition. The White Way Laundry (409 Brady Street), Hall and Martin Art Shop (401), and Charles P. Shaffer's Restaurant (422) are among the businesses that can be seen in the background.

A century ago, parades were large affairs that the entire town participated in and turned out to enjoy. This floral swan entry heads for the rendezvous and proved to be the head turner in this parade in 1908. Journals and magazines often referred to Davenport as the "City Beautiful – flower boxes fill the office windows and vacant lots were planted in smooth lawns and gay flowerbeds."

This float from the 1916 parade reads, "Let Us Save Your Soles" and is parked in front of its sponsor the H. Steffen Leather Company (315 West Third Street). Postcards such as this were sometimes used as advertising in normal business correspondence.

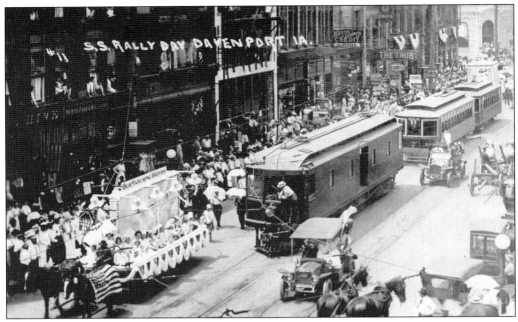

The author's grandmother rode on the wagon in the first float as a little girl. How exciting it must have been to be a part of the bustle and hoopla of the entire town. Dignitaries, marching bands, bicycles, horses, automobiles, interurbans, and streetcars crowd the streets in this Sunday School Rally Day Parade in 1910. Back in 1888, Davenport became the first city west of the Mississippi to electrify its street railways.

Florizel Von Reuter, born in Davenport in 1890, was a child prodigy, composer, and author who spent much of his life playing for the crown heads of Europe and ultimately headed the Vienna State Academy of Music. In 1949, the concert violinist found himself in Berlin, broke and hungry. He died in 1985, relatively unknown to his hometown.

Hans Reuter clears the bar in an early track contest for Davenport Central Turner's. His father, William, was supervisor of physical training in the public schools. Fitness was practiced via traditional German instruction in marching and the use of Indian clubs and dumbbells. Around 1920, the Davenport public schools adopted "physical education" programs, which decreased the importance of the Turnegemeinde, or Turner Society, training, concentrating instead on American team sports and games that could be played at recess.

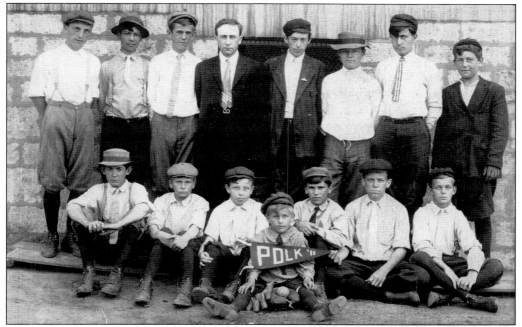

Polk School, located at 1212 West Eighth Street, captured the grammar school baseball championship (around 1912). The Zion Lutheran Church now occupies the location of this school on the corner of Eighth and Marquette Streets.

Across America, People are Discovering Something Wonderful. *Their Heritage.*

Arcadia Publishing is the leading local history publisher in the United States. With more than 3,000 titles in print and hundreds of new titles released every year, Arcadia has extensive specialized experience chronicling the history of communities and celebrating America's hidden stories, bringing to life the people, places, and events from the past. To discover the history of other communities across the nation, please visit:

www.arcadiapublishing.com

Customized search tools allow you to find regional history books about the town where you grew up, the cities where your friends and family live, the town where your parents met, or even that retirement spot you've been dreaming about.

MAP SEARCH